A Modern
Photo
Guide

Portrait Photography

Minolta Corporation
Ramsey, New Jersey

Doubleday & Company
Garden City, New York

Minolta Corporation
Marketers to the Photographic Trade

Doubleday & Company, Inc.
Distributors to the Book Trade

Library of Congress Catalog Card Number 81-71229
ISBN: 0-385-18160-4

Cover and Book Design: Richard Liu
Typesetting: Com Com (Haddon Craftsmen, Inc.)
Printing and Binding: W. A. Krueger Company
Paper: Warren Webflo
Separations: Spectragraphic, Inc.

Manufactured in the United States of America
10 9 8 7 6 5 4 3 2 1

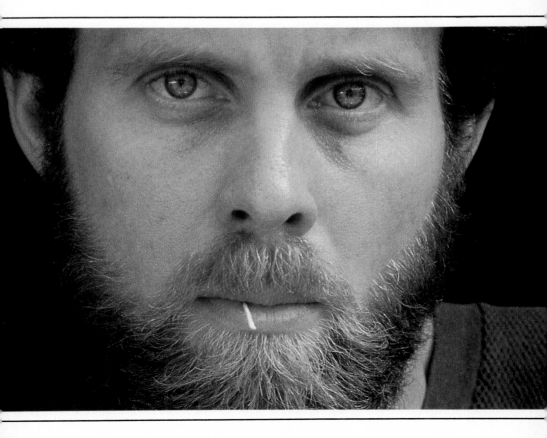

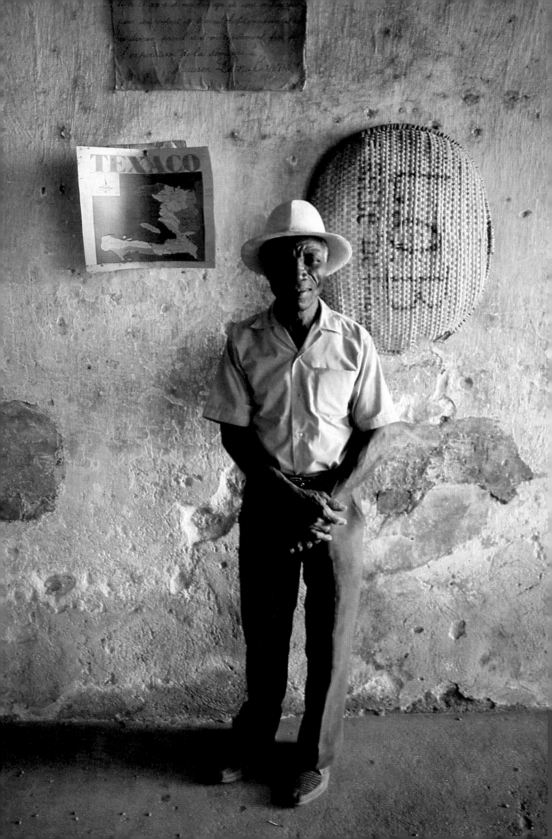

Contents

Technique Tips

Throughout the book this symbol indicates material that supplements the text and which has been set off for your special attention. You can apply the data and information in these Technique Tips immediately to get better results in your photography.

ntroduction

What do you think of when someone mentions a photographic portrait? Most people describe the kind of picture made by their local portrait and wedding photographer: one with artificial lighting and a formally seated, stiff subject dressed in Sunday best and perched in front of a background resembling a prop from a bankrupt theater company. No wonder, then, that many people balk at the idea of "having their portrait taken."

Portraiture in the true sense has nothing to do with the situation described above, although some real portraits have been made under such conditions. What is a portrait? Whether it is made with oils and canvas, chisel and stone, or camera and film, a portrait is nothing more than a perceptive look at someone—a look that captures the unique properties of the individual being portrayed.

This uniqueness is often subtle and evasive, which is why so many portraits fail to convey it. Often they describe the appearance of the subject, instead of showing what and how the person really is.

Photographic portraits have been made since the earliest days of photography. The daguerreotype—and later glass—plates used then were relatively insensitive to light and required extremely long exposures. Sitters were expected to hold still for several seconds, or even minutes. Special "portrait chairs" were needed, with built-in arm and neck braces to keep the subject motionless. Because of this, and because of the mystery surrounding the then new practice of photography, both the sitter and the photographer approached portrait making as though it were some sort of arcane rite. The pictures made in those days show this. Unfortunately, the same attitude crops up even now, making portraiture more difficult at times than it ought to be.

This book is about seeing people as they really are, and photographing them in a way that allows other people—viewers—to share what the photographer has seen.

Focus in a tight close-up can be critical. In almost every case, concentrate on making sure the subject's eyes are sharp—that's where we make contact with the individual. Photo: B.

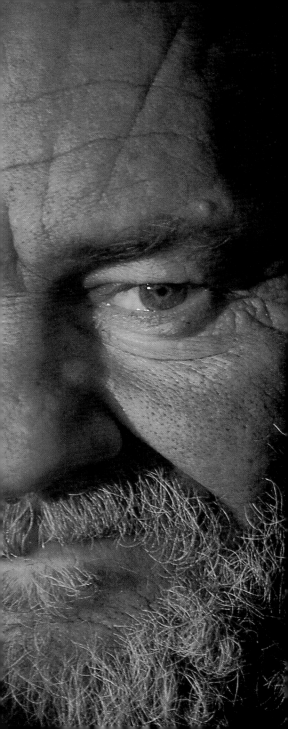

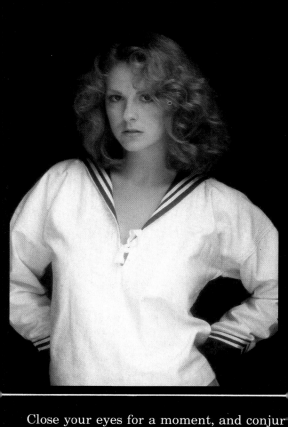

Close your eyes for a moment, and conjur
the most important person in your life. What
certain gesture, a tilt of the head, a smile? Is it
form around the eyes when the person is exci
complete picture of the person, seated in a favo
some special task? These are the things that m
—these are also the things from which real p

Making a photographic portrait is at the
simple and most challenging. The simple part
traits can be made with the most basic photog
one camera, a lens, and a roll of film, you are fu
ture. Although special lenses, lights, and access
options regarding the kind of picture you can r
necessarily make your portraits any better. I
mistakenly assume that bags full of equipment
of anything, the opposite is true—the less photo
you have to fiddle with, the less chance you
interest and relaxed attention of your subject

Your subject presents the challenging as
effectively capture his or her individuality, you
and not only conscious cooperation. Unconsc

relaxed and willing to put aside his or her emotional defenses long enough for you to photograph the individual underneath. These moments are usually few and very short, so you must be patient, and prepared.

The following sections discuss the various types of equipment and the techniques available for photographic portraiture. There are also suggestions about how to overcome the nervousness of the people in front of your lens, and about kinds of portraits you might try. Some of the methods and suggestions may work better for you than others. There are no hard and fast rules here regarding the *correct* way to make portraits—*correct* is whatever gets the portrait you have in your mind's eye onto film.

With practice, attentiveness, and enthusiasm for people you will soon find yourself possessing one of the most gratifying skills a photographer can have—the ability to make successful portraits.

When one member of a group is to be dominant in the picture, add a feeling of unity by having the others lean toward or touch the central figure. Photo: M. Heiberg.

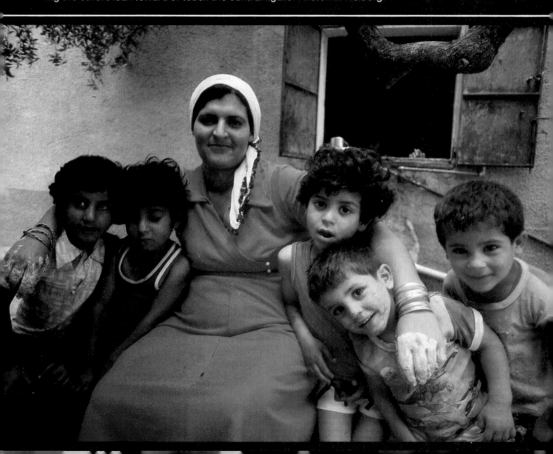

1

Formal vs. Informal Portraits—Which to Make

The difference between formal and informal portraiture has little to do with location, equipment, or lighting. Irving Penn has made formal portraits of tribesmen in New Guinea, and extremely informal ones of movie stars in his New York studio; in each case he used the same kind of large-format camera, carefully controlled lighting, and studio background.

Formal and informal portraiture are different only in the attitudes of the photographer and the subject and in the photographer's approach; differences in equipment are secondary. What is most important for you to decide is what kind of person your subject is, and how best to record the attributes that make him or her special.

Most people you will encounter will react reasonably well to the idea of being photographed, but those same people might be a little uneasy about sitting for a portrait. Having pictures taken is by now a familiar experience for most people, but portraiture still has aspects of a formal event for many. You probably feel the same way yourself—most photographers do.

Some people react in the opposite way. They are flattered by the attention they get during a controlled, formal portrait session, but often are uncomfortable sitting casually while you photograph them informally.

You yourself might function better as a photographer in either a formal setting or a casual one. You should examine both methods of making portraits and then develop a sense of which approach will best suit particular subjects.

Formal or informal portraiture is as easy or as difficult as you want to make it. To be successful at either, you must have a clear understanding of what you want to have on film when the shooting is over.

Directness, warm, unified colors, expressive light, and above all a genuine appreciation of the subject all combine to produce a rich portrait, one which shows that dignity is not a matter of formality. Photo: B. Krist.

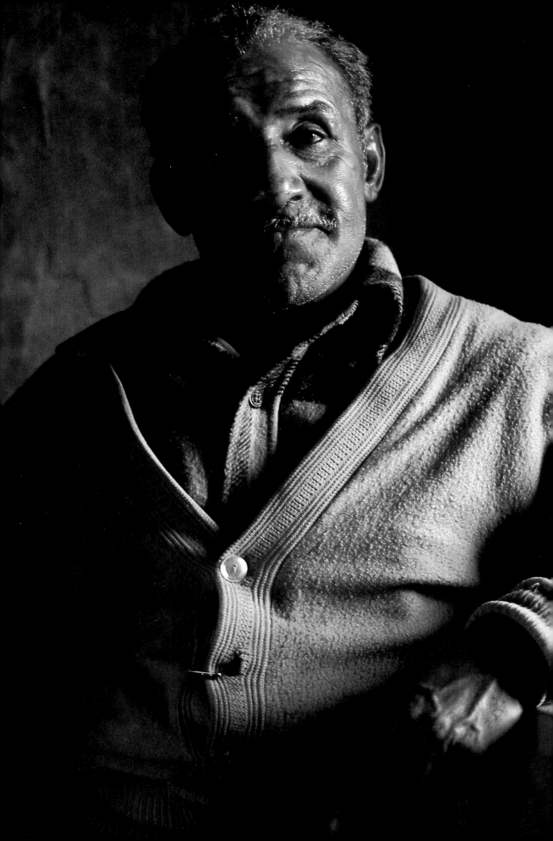

Formal Portraiture

Formal portraiture is the most painterly of portrait methods. The physical characteristics of the subject are as important as the emotional ones; both photographer and subject actively participate in the making of the portrait; and the final product usually has the same aim as a painted portrait does—to celebrate the existence of the individual portrayed. Formal photographic portraits, like formal painted portraits, are meant to hang on someone's wall.

Formal portrait making is a serious business. But that does not mean that it has to be a solemn one. Most formal portraits that fail do so because the people involved took themselves and their portrait making too seriously. The event became more important than the end result.

All you need to make effective formal portraits are the following:

- A neutral or unobtrusive background.
- Carefully planned, but not necessarily complicated, lighting.
- A standard or slightly long focal length lens.
- The slowest, finest-grain film you can use in the lighting situation.
- A tripod.
- The cooperation of your subject.
- A good sense of your subject's personality, and a need to get it on film.

Because portraits usually end up as photographic prints, use fine-grain, slow films, whether shooting in black and white or in color. Formal portraits deal with the physical appearance of the subject as much as anything else; fine-grain films will record the subject's features with more fidelity than fast films will.

Slow films also have another advantage: They require longer exposures in natural light or nonelectronic artificial light, so the subject will have to concentrate a bit on keeping still, usually for about 1/2 sec. In that time, most subjects will lose the nervous facade they put on while in front of the camera, allowing you to photograph the person underneath.

Formal portraits are usually *confrontational*—the subject is shown looking directly, or almost directly, ahead. The image confronts the viewer. For this kind of photograph to be most successful, the final print should be reasonably large. Small portrait prints, or reproductions in a book such as this, are rarely as powerful as half-life-size prints (for head-and-shoulders or face portraits). Print sizes of 11″ × 14″ and 16″ × 20″ are both commonplace in formal portraiture. For this reason, many portrait photographers prefer large-format cameras for their formal sessions. Bigger negatives require less enlargement, and big prints retain the physical quality contained in the negative.

To avoid an overly stiff look in a formal portrait, have your subject doing or holding something characteristic. Photo: T. Tracy.

Informal Portraiture

Informal portraiture is the simplest and, in many ways, the most rewarding form of portraiture. It can be done easily with small cameras and ordinary lenses, anywhere you and your subject happen to be. The subject does not even have to know that you are making a portrait. He or she might just assume you are making a snapshot.

Posing and Composition. The days of prescribed composition are long gone. What makes a portrait work is how the subject is, not whether he or she is located in some "proper" part of the picture. Posing, especially in informal portraiture, is a silly idea at best.

Unfortunately, many people automatically pose for the camera, having been taught to do so by their snap-shooting parents long ago. There are two ways around this problem. The first is to wait a moment after raising the camera until the posed look wears off. The other, and usually more successful, way is to waste the first few exposures photographing the posed look, and then shoot the picture you want between poses. If you do this smoothly enough as you talk about something of mutual interest, the subject will not realize that your shutter is going off between expressions.

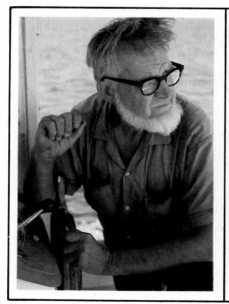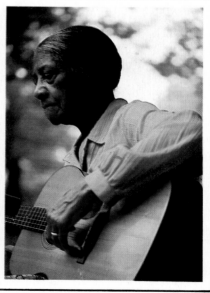

Three factors can add greatly to informal portraits: soft natural light, environmental details such as the boat wheel and the guitar, and a revealing angle of view. Photos: (left) J. Child; (right) B. Barnes.

Technique Tip: Eye Contact with Your Subject

The smaller your camera, the more careful you will have to be with respect to both your technique and your subject. Because small cameras such as the 35mm single-lens reflex models are most often used at eye level, your subject will be seeing you with one of your eyes glued to the camera most of the time. Some people find this very disturbing.

Larger-format cameras—roll-film and view cameras—are generally used at the photographer's waist or chest level. Your subject will see more of you more often if you use one of these. It will be easier to establish eye contact, which most subjects find pleasant and reassuring, and to carry on a normal conversation. The picture will be better because your sitter will be more relaxed.

If you plan to make formal portraits with your 35mm camera, get a waist-level viewfinder for it. If you do not have one, focus the camera quickly, remember where the subject is situated in the finder, and look *directly* at your subject—not through the camera—as you shoot. This is especially easy to do when the camera is mounted on a tripod. If you keep your head reasonably close to the lens as you shoot, the sitter will appear to be looking into the camera.

Relaxing the Subject. Your subject is more likely to be him- or herself if the word *portrait* is not used. This will allow you to record the characteristic moment, expression, or gesture that separates your subject from all other people. Informal portraits do not require the subject to look directly at the camera, nor do they require you to pose your subject. Think in terms of recording your subject's natural way, having first developed a mental image of what that means to you.

Pay attention to the light. If you are shooting outdoors, try to position your subject so that his or her face is well lit, with shadows helping give the face dimension.

Shoot your portraits in surroundings comfortable to the subject. This will put both of you more at ease. People are far more relaxed in their own "territory" than in a portrait studio. In addition, photographing a subject in his or her surroundings might help you in unexpected ways; he or she might pick up some special object, or sit in a place that allows a typically expressive gesture or bodily position to occur. You will find more subject matter for conversation, as well.

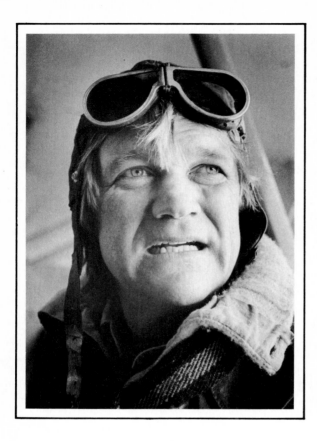

The background need not be highly detailed to add meaning to a photograph. Just the suggestion of a wing strut from an antique bi-plane in the upper right serves to set the scene for this portrait.
Photo: N. deGregory.

Character Studies and Environmental Portraits

Character studies fall between formal and informal portraits. If you are consciously trying to photograph one specific aspect of a person —for example, strength, softness, courage, or simplicity—you are making a character study. If you are successful, the viewers of your portraits will be able to form reasonably accurate conclusions about the subjects in them. If you fail, your pictures might look a little corny and shallow.

Paul Strand's photographs of farmers and country people in Europe and elsewhere are excellent character studies—the industry and hard life of the people portrayed come across strongly in their faces, their hands, and the intense expressions in their eyes. Every one of these pictures gives you a good idea of what life is like for all people in truly rural areas. In contrast, the photographs of gin-soaked derelicts, wrinkled old men, and gnarled hands on walking sticks that hang on the walls of many camera clubs are examples of unsuccessful character studies. Such pictures are more records of stereotypes than they are portraiture.

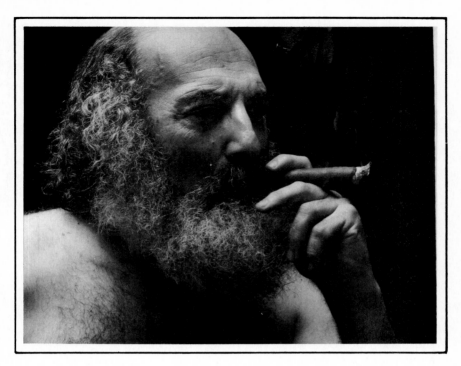

When you feel that some physical aspect of your subject (such as a full beard) is very important to his personality, accentuate it with careful lighting. Photo: J. Alexander.

Technique Tip: Avoid Caricatures

If you are interested in doing a character study of someone, plan the picture carefully and avoid cliches. If you are making a character study of a sleeping child, stay away from thumbs being sucked. If you want to do a character study of your grandmother, avoid photographing her as she peers over her eyeglasses, smiling.

Character means characteristic nature. If you think about your subject as a whole person, rather than the possessor of one particular trait, you might bypass the whole idea of character study, and concentrate on making a formal or informal portrait instead. If you think of the subject as "just like" an old seaman or something of the sort, you are on the wrong track. You are making an illustration about a *type*, not a portrait.

Environmental portraits. Environmental portraits use the background or surroundings as an integral, expressive part of the picture. A conductor standing at the podium and a news vendor at his or her stand are both examples of environmental portraits.

In a good environmental portrait you can tell as much about the subject, if not more, from the surroundings as you can from the person in the picture. It is even conceivable, though difficult, to make a successful environmental portrait that has *no* person in the picture.

There are two general types of environmental portraits. The first celebrates a person and what he or she does. If you were to photograph an artist in his or her studio, with some canvases in the background, you would be making this kind of environmental portrait.

The second type is the portrait that includes an editorial comment. Pictures of young children working in a factory at the turn of the century, of displaced youngsters asking the viewer to send money to CARE, and of soldiers tired and bloodied in battle are all examples of editorially slanted environmental portraits.

Opportunities to make the first type of environmental portrait are all around you. Think of all the people you have dealings with every day—your fellow workers, owners of shops you frequent, your bank teller. These people and many more are in their work environments whenever you see them. All are candidates for environmental portraiture.

The 35mm camera is perfectly suited to this kind of photography. Using it requires little preparation; the standard lens is usually fast enough—even in low light—for you to hand-hold your camera with little fear of blurring the image; and it is small enough for you to carry with you throughout the day.

Begin your environmental portraiture by getting the people around you used to the camera. If you decide to photograph a friendly shopkeeper, for example, bring the camera with you a few times as you shop. Sooner or later the conversation will turn to your camera. As you describe it, make a picture of the shopkeeper; then later give him or her a copy. If your photograph was at all successful, you should have no problem getting your subject's permission to shoot a few more exposures.

Use black-and-white film for the first photographs of your subject. Give him or her prints—prints are more impressive to nonphotographers than transparencies are, and prints will probably end up in the shop window or on the wall for customers to see.

If your subject works inside, use a fast film such as Kodak Tri-X so that you will not have to use electronic flash. Environmental portraits are best done with available light.

Make sure that when you try this your subject is not busy with other things. The fastest way to lose a shopkeeper's interest in posing is to have him or her lose a sale while doing so.

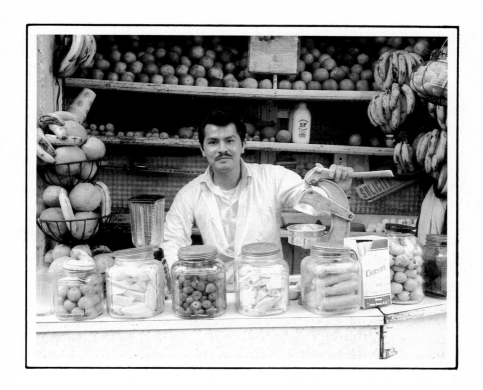

Shopkeepers are proud of what they do, but don't try for an environmental portrait at a busy time of day. You will both be more pleased with the results when you have time to work together. Photo: B. Sastre.

Make mental notes the first time you photograph about how your subject reacts to the camera, and to your conversation. Use your first tries as sketches for the next time so that, when you come back, both you and your subject will be better prepared.

Public places, such as train stations and parks, are vast storehouses of human behavior on display. In parks and zoos, people are generally more relaxed and self-possessed than they are on the street. In bus and train stations, they are preoccupied with going to or coming from work, business, doctor appointments, or the like; their worries, troubles, and tiredness show in the way they hang their shoulders, set their faces, and wear their hands. To a portrait photographer, watching people is research—the way that listening to natural sounds is to a composer. Being observant about people in general will make you more observant about your portrait subjects.

When One Picture Is Not Enough—Series Portraits

There is no law that a photographic portrait must consist of only one picture. Sometimes a characteristic gesture or expression is best captured in two, three, or more photographs.

For example, let us say that you want a portrait of someone who uses his or her hands a lot, with each gesture connoting something different. You might be able to indicate something about that person by capturing one of the hand movements, but why stop there? A series of such movements may tell much more about the person.

Consider another example. The woman you are photographing has a particularly expressive face, especially when she smiles. The smile begins slowly at the corners of her mouth, then builds, finally breaking into an impish grin. Which part of the smile is most like her? Probably all of it. The most effective way to portray it would be to show the growth and full blossoming of the smile, rather than just one part.

Some people have backs that are just as expressive as their more conventionally portrayed front, or sides. Why not show both front and back?

This kind of portraiture will work equally well in color or in black-and-white. Obviously, it needs to be presented in print form to be effective, and the prints will have to be exactly the same in tone and size for the portrait to work properly. Continuity is all important—if your subject is smoking a cigarette and the series of pictures takes some time to produce, make sure that the pictures you end up using all show

the same kind of cigarette, at the same length. If your subject is holding a glass of wine, a piece of bread, or other food, be careful not to have it half eaten or drunk in the first picture, and full or whole again in the next.

Make sure that the background and foreground stay the same. The object is to call attention to the changes in your subject, not in the surroundings.

Use fast films for this kind of portraiture; more often than not, it will involve some degree of movement. Fast films will allow use of high shutter speeds with which to stop the movement.

Series portraits will obviously be possible only with your intended subject's cooperation and knowledge of what you are doing. Explain what you are after, and if your subject agrees, you might try to shoot your series portrait in a controlled environment. Seamless paper or a similar featureless background will not compete with your subject in the final image.

A word of warning: This kind of portraiture is not a good way to salvage a poorly executed regular portrait session. In order for a series portrait to work, each of the pictures should be able to stand alone.

The problems and difficulties you find while doing a conventional, single-image portrait are multiplied by the number of images in a series portrait. A good series portrait consisting of three images is at least three times more difficult to achieve than a good single portrait.

You will fail quite a bit at first, but you will learn a tremendous amount as well, and everything you learn will enhance the other types of portraits you make.

During an event with changing action, take a number of pictures to be sure of capturing a good facial expression. Use a long lens set at a wide aperture to isolate the main subject from a group; a 135mm lens at f/3.5 recorded this sequence. Photos: J. Child.

2

Making Your Equipment Fit the Task

You can buy a simple, very inexpensive pocket camera and use it to make portraits that get at the very core of your subject's personality. You can also take out a second mortgage to purchase a camera and lens, and then come away from a portrait session with nothing more than meaningless representations of your subject's appearance. As in all forms of photography, the camera does not create an effective photograph, you do.

This is not to say that fine equipment cannot help you get better photographs. It can and will help you transfer photographic ideas from your mind's eye to film, but the ideas have to be there in the first place.

Make a list, then establish your priorities. Keep in mind that the less equipment you have to worry about, and the simpler it is to operate, the more time and energy you will have to spend on your subject. If, for example, you own both a 35mm camera and a view camera, but feel more at home with the 35mm, use it for important portraits even if the view camera could be used. Become comfortable with your view camera on your own time before trying to put it to use. However, if you are equally at home with both, and either can be used for a particular portrait situation, use the view camera for the better image quality it will give.

By far the most important consideration is yourself. Successful portraiture is largely a matter of instant reaction to changes in your subject's expression. There is no way you can be ready to react if you are using the occasion to get on-the-job training with unfamiliar equipment. Use the equipment with which you are most familiar and comfortable, even if it is that inexpensive pocket camera mentioned earlier. Familiar photographic equipment is like an extension of your eyes; and no piece of sophisticated machinery has ever taken the place of an active imagination.

One-twenty size film produces a 2 ¼ " × 2 ¼ " negative—significantly more area than a 35mm one. The result is much less graininess in prints of the same size. Photo: J. Alexander.

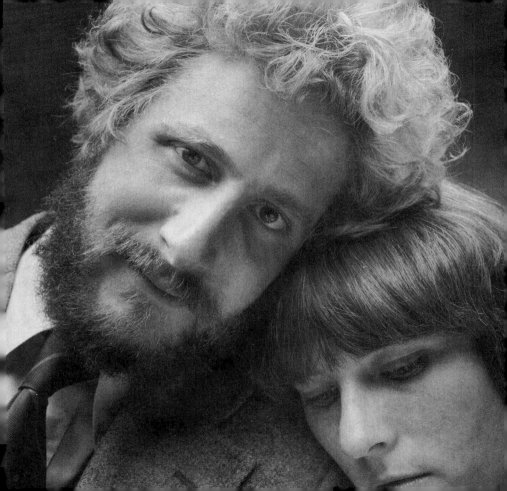

35mm Portraiture

Your 35mm camera is an ideal tool for portraiture, especially informal and environmental portraiture. The 35mm cameras and lenses are light, fast, and unobtrusive, and are equally suited for use indoors on a tripod or outdoors in your hands.

Single-lens reflex 35mm cameras are the easiest to use for portraiture. They allow you to see exactly what the lens will record, so you can frame your subject and the background without worrying whether the lens "sees" the picture as you do. Most single-lens reflex 35mm cameras have interchangeable lenses, giving you the opportunity to make wide views of your subject, full-figure shots, head-and-shoulders portraits, or facial closeups, all from one position.

SLRs do have one disadvantage, however. They are designed with a viewing mirror that moves upwards as the exposure is made. When the mirror is in the up position, you are unable to see your subject at all through the camera. This blindness is momentary, and you can get used to it easily.

Not every person in a photograph has to be in focus. It's perfectly acceptable to allow a secondary subject to go a bit out of focus in order to direct attention or suggest a relationship. In this picture we see a portrait of a person and a companion—not of two people. Photo: K. Tweedy-Holmes.

One advantage of 35mm photography is economy—each frame is relatively inexpensive. So, try your picture ideas in many different ways; sometimes the obvious framing is not the most interesting. Photo: S. Pfriender.

The 35mm rangefinder cameras are also easy to use for portraiture and are made in such a way that there is no blacking out of the finder during exposure. However, when you use a 35mm rangefinder camera, you are not looking at your subject through the taking lens; instead, the subject appears in a finder above the lens. If you are close to your subject, the finder may show you a slightly different view of the subject than the lens sees; the difference in viewpoint is called *parallax*. The more expensive versions of this camera type have parallax correction marks or frames in the viewfinder to help overcome this problem.

Only one or two very expensive rangefinder cameras have interchangeable lenses; in most cases, you will have to make do with the lens your 35mm rangefinder comes with.

For conventional portraiture, where your subject is the main part of the photograph and the background is merely support, use a standard or slightly long-focal-length lens. The standard lens is best for three-quarter shots of your subject, or full-figure shots with your 35mm camera held vertically.

The long-focus lens (between 75mm and 135mm) is better for portraits of your subject's face and for head-and-shoulders portraits. Longer lenses are positioned farther from the subject than standard lenses are for these kinds of portraits. Standard lenses will distort the subject's features slightly if used at too close a distance. The distance you must maintain from your subject while using the longer lenses will lower the risk of your sitter being made nervous by the closeness of the camera.

For all conventional 35mm portraiture, indoors and outdoors, use the slowest, highest-resolution film your lighting will allow. Portraits of all types rely a great deal on good rendition of the subject's features, and the small size of the 35mm negative makes grain-free, highly detailed enlargements difficult unless slow, fine-grained films are used.

Environmental 35mm portraiture usually requires the use of standard or wider-than-standard lenses. If your subject is to be photographed in an enclosed space such as a shop, an office, or the cab of a truck, you will need a 35mm or a 28mm lens so that the surrounding area will be part of the picture. If your subject's environment is a large one—a church, a construction site, or a playing field, for example—the use of a 35mm, a 28mm, or even a 24mm lens will help you get all the area on film.

Spontaneous expression is often the key to a candid portrait—stay alert for that moment. Photo: P. Bereswill.

Environmental portraits of the more intimate sort—a portrait of a potter at his or her wheel, or one of a woodwind player with a piccolo in hand—can be done with long-focus lenses. Depending on your positioning of the camera, you can make accompanying objects appear to be integral parts of the subject; the slightly compressed perspective of long lenses will help tie together the subject and relevant objects around, or held by, him or her.

When shooting portraits with a 35mm camera, try to look at your subject without peering through the camera during exposure. This will take care of the SLR's blackout problem and will make your subject feel more at ease than if you kept your eye glued to the finder.

Almost all 35mm cameras have their focusing aids centered in their finders. But this does not mean you should always center your subject. If you use a 35mm rangefinder, focus on your subject, then move the camera until you get the desired framing before releasing the shutter. Sometimes this takes conscious effort, especially if you are excited by what you see. Make the effort, and you will not be disappointed by your pictures.

This also applies to SLR cameras. Focus, then frame your subject; or frame, then focus the outside parts of the focusing screen. Better yet, get a screen that is all ground glass, with no aids. Then you will not be tempted to center the subject constantly.

Keep shooting when you are trying to grab a portrait during action. Background, expression, and pose problems (left) may disappear in the very next frame (right). Photos: B. Sastre.

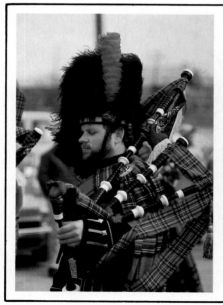
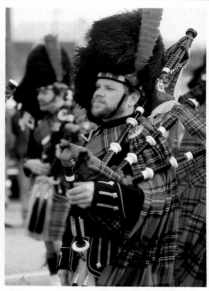

Roll-Film Portraiture

Roll-film cameras combine much of the portability and shooting ease of 35mm cameras with the better image quality of large-format cameras. The Hasselblad, the Rolleiflex, the Pentax 6 × 7, the Plaubel Makina, and similar cameras are used daily by commercial and editorial photographers who have to produce high-quality portraits for magazines or advertisements.

Most current roll-film cameras are single-lens reflex models, with interchangeable film backs and lenses. Both the camera bodies and lenses of the better models have extremely high-quality, precision-built mechanisms, many of which are individually handmade. Because of this, these cameras are very expensive. A typical Hasselblad outfit, with one body, two backs, and three lenses, can easily cost as much as some automobiles.

Equipment such as this is beyond the means of most photographers. If you are interested in the higher quality produced by a larger negative but do not have the funds to own a camera such as a Hasselblad, take heart. A number of less expensive, though less versatile, roll-film cameras are still made. One of these is the Yashica-Mat, a twin-lens reflex camera (you look at the subject through one lens, while another lens of the same focal length makes the picture). If you want interchangeable lenses, you might look at the Mamiya C-220, another twin-lens reflex camera selling for far less than the sophisticated machines mentioned earlier.

Used roll-film rangefinder cameras and discontinued classics like the Rolleiflex Twin-Lens Reflex can be had at a reasonable price. These usually have the same lenses as the very best roll-film cameras currently made; their rangefinder or twin-lens design has lost its popularity over the past ten years or so, making them one of the best photographic bargains you are ever going to find. A "Rollei" in good condition will provide both you and your grandchildren with years of technically superb pictures.

Roll-film cameras are equally suited to formal, informal, and environmental portraiture. These cameras, while not as small or light as 35mm equipment, can be carried just about anywhere; the larger negative size allows big prints to be made easily; and the cameras are not bulky enough to intimidate nervous subjects.

The standard lens for most roll-film cameras is between 75mm and 105mm in focal length. Depth of field is shallower with these lenses than with standard lenses for 35mm cameras; at each f-stop, less of the area in front of and behind the subject is sharply rendered. This is an asset when you want to suppress background details in order to make your subject more prominent in the picture.

The image size of roll-film cameras varies with the camera model. Most provide an image area that is about 6cm square. Some give a

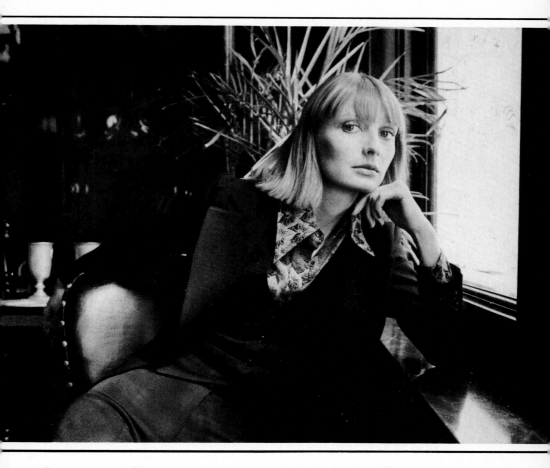

Because most roll-film cameras have top-viewing finders, the lens level of view for a standing photographer is chest- or waist-high. This makes eye-level portraits of seated subjects easy to take. Photo: J. Alexander.

rectangle that measures 6 × 7cm or 6 × 9cm; still others give a 4.5 × 6cm image area. Some cameras of this type have interchangeable backs that allow for the use of more than one format with the same camera.

The standard roll-film size is 120, which produces twelve 6 × 6cm images, sixteen 4.5 × 6cm images, ten 6 × 7cm images, or eight 6 × 9cm images per roll of film. This seems like very little when compared with the 36 exposures you get from one roll of 35mm film, but the lesser number of exposures is more often than not an asset. It forces you to concentrate more on each exposure; your shooting becomes a little better thought out, and more methodical.

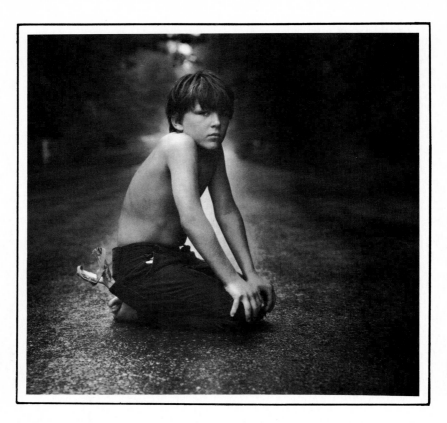

Use a variety of techniques to concentrate attention on your subject. Here, both shallow depth of field for selective focus and extra exposure (burning-in) of the outer edges during printing were used to increase the effectiveness of the image. Photo: J. Alexander.

Use your roll-film camera on a tripod whenever possible, especially if your portraits have an appreciable amount of background. The depth of field needed in such cases will require small lens openings and slower shutter speeds. Roll-film cameras usually cannot be hand-held at the same slow exposures that 35mm cameras can.

The waist-level finders in most roll-film cameras can be problematic until you get used to them. They show a right-side-up but laterally reversed view of your subject. As he or she moves the right arm, the left arm of the image in your finder will move, and so on. Unless you train yourself to mentally "switch over," you may find your subject doing exactly the opposite of what you have asked for.

At close focusing distances, the view shown by a twin-lens reflex camera is inaccurate, both in parallax and in perspective; the viewing lens is located far enough above the taking lens that you might see only some of what the film is recording, and at a different angle. Some camera makers have special, perspective-correcting attachments for their twin-lens reflex models. If you plan to shoot closeup portraits, get one.

Technique Tip: Selecting a Format

Foreign manufacturers give format dimensions in mm or cm; U.S. manufacturers use inches. Equivalent formats are:

35mm film	24 × 36mm	1 × 1.5 inches
120/220 film	4.5 × 6 cm	1¾ × 2¼ inches
	6 × 6 cm	2¼ × 2¼ inches
	6 × 9 cm	2¼ × 3¼ inches
4 × 5 sheet film	10 × 12.7 cm	4 × 5 inches

A square, or nearly square, format lets you easily crop to either a horizontal or a vertical rectangle when a print is made.

The larger the format, the easier it is to judge results from contact (same-size) proof prints, and to have the negative retouched, if necessary.

A small format requires a greater degree of enlargement to achieve a desired print size. This may make film characteristics such as graininess unpleasantly noticeable.

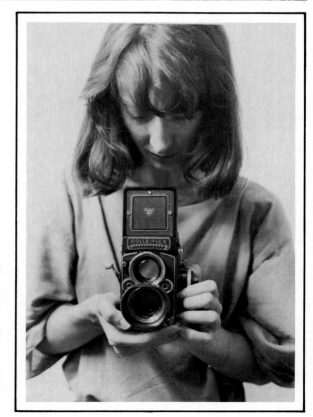

Twin lens reflex cameras, while not as popular now as they once were, provide either waist- or eye-level views of the subject, a large negative, and quiet, vibration-free operation. One main advantage of twin-lens reflex cameras is that they have no moving mirror to block your view of the subject during exposure.

View Cameras in Portraiture

View cameras are the classic portraiture tool. With their large film size, ground-glass focusing, and darkcloth, under which the photographer disappears while sharpening the image, view cameras are standard equipment in commercial portraiture studios and in the ateliers of world famous portraitists like Richard Avedon, Irving Penn, and Arnold Newman.

The view camera is the oldest type of photographic machine. It has not changed much in design since its inception over a century ago and, in spite of the improvements that have been made, still has the same advantages and drawbacks it had then.

View cameras consist of a front and rear standard, a bellows, and some sort of supporting mechanism that holds these things together (usually this is a monorail). The front standard contains a lensboard; the bellows moves back and forth to focus the lens; and the rear standard has ground glass on which the image is focused. The entire machine resembles a light-tight accordion adapted to photography. When the lens is focused, you slide a film holder in place of the lensboard, remove a "darkslide" to let light reach the film, and then make the exposure.

The standard film sizes for view cameras are 4″ × 5″, 5″ × 7″, and 8″ × 10″. Some smaller and larger film formats for the view camera do exist, but they are rarely used anymore.

The view camera takes one piece of film at a time, so its use is slow and painstaking. The image you see on the ground glass as you focus is upside down, laterally reversed, and dim when compared to 35mm or roll-film images. To prevent ambient light from interfering with the brightness of the view camera's focusing screen, you must use a darkcloth over the camera back as you focus.

Lenses for view cameras are quite slow by small-format standards; few have maximum apertures larger than $f/4.5$, and their long focal lengths (between 200mm and 500mm, depending on the format) make sufficient depth of field at wide apertures almost nonexistent.

The view camera must be used on a tripod; it is extremely cumbersome, heavy, and obtrusive. In view of these things, the view camera might sound like it is more trouble than it is worth. However, the quality produced by a properly used view camera can be matched by no other camera type. The smallest details of the subject are rendered with astonishing fidelity. Facial features, clothing texture, and even eyelashes appear more than real; and a sharp view camera negative can be enlarged to mural size without losing much of the quality.

Consider this: A 35mm negative enlarged 10 times produces a 10″ × 15″ print of reasonably good quality if printed carefully. A 4″ × 5″ negative made on the same type of film will produce a 40″ × 50″ print with the same quality. When an 8″ × 10″ (20 × 25 cm) view

camera negative is enlarged 10 times, the result is an 80″ × 100″ print; such a negative is large enough to produce a life size, full-figure portrait of the tallest basketball player you can name, with space left over!

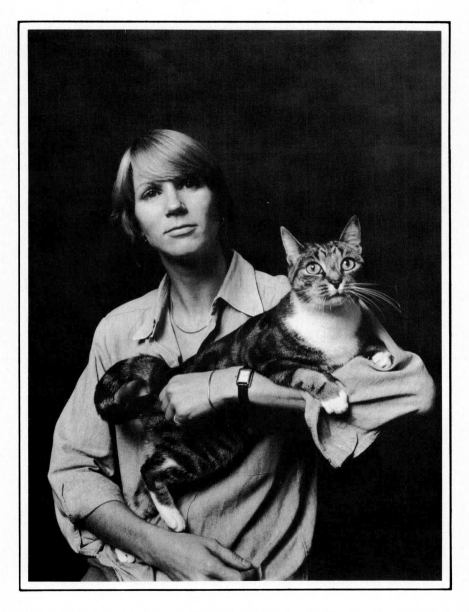

View cameras are most appropriate for posed pictures. Take advantage of the quality and precision they can achieve by controlling the light carefully for the best rendition of subject qualities. Photo: A. Balsys.

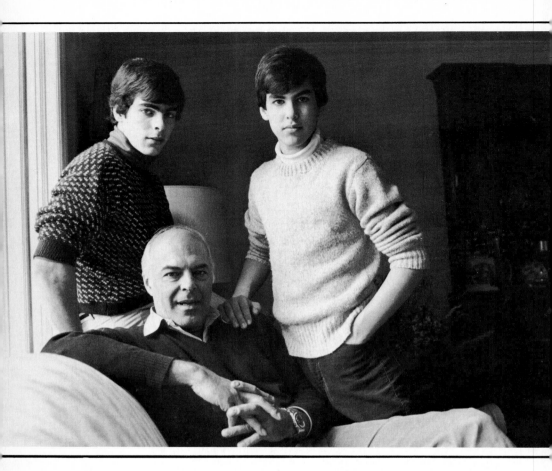

Make sure your subjects are comfortable and can easily hold the pose you've chosen. Even the most co-operative persons will appear frozen if they're ill at ease. Photo: J. Alexander.

View-Camera Exposure Procedure

View cameras are best suited to formal portraiture where the subject is ready and willing to be photographed. Working with a view camera is time consuming and extremely difficult at first. You must set up lights, or find a bright enough area outdoors. Then you must place your subject where you want, moving the view camera and its heavy tripod around your subject to get the best vantage point.

When you have done this, you must open the lens shutter, and the diaphragm to its widest aperture, so you can see to focus. At that point you must disappear under the darkcloth for a few moments to focus the camera. When the camera is focused, you measure the light falling on your subject, close the lens shutter, stop down the lens to the appropriate aperture, insert a film holder, remove the darkslide, and expose.

While all this occurs, you must keep the subject relaxed and interested in the proceedings. If you succeed, you will have one negative or transparency exposed. The entire process must be repeated for each exposure—unless the sitter has not moved at all and the light has not changed, in which case you can dispense with focusing and light readings. No wonder most photographers who use view cameras for portraiture do so in studios, where the light is constant and the subject-to-camera distances have been measured out beforehand.

View-camera exposures are usually longer than those made with other camera types. This is due to the smaller apertures needed on the longer view-camera lenses for good depth of field. The result is that your sitters will become subdued while waiting for the exposure to end. Sometimes, if you are lucky, their masks will drop, and your view camera will record what is beneath the facade your subject usually presents.

Technique Tip: View-Camera Portraiture

The real advantage of a view camera for portrait work is not the extent to which the negatives can be enlarged, but has to do with three things:

1. The image quality achieved when the negatives are enlarged moderately.
2. The ease with which the large negatives can be retouched (in order to make fat, wrinkled, and vain portrait clients appear pounds lighter and years younger).
3. The flexibility of the view-camera bellows, which allows the lens and film to be moved about in relation to each other. By moving the front, the rear, or both standards of a view camera, you can correct distorted areas of your subject.

Black-and-White Films for Portraiture

Most film manufacturers offer several "professional portrait films" among their black-and-white products. You might think that this designation means a film with some properties that make it more suited to portrait making than the black-and-white film you normally use. Not true. In the vast majority of cases, the term *portrait film* refers not to the emulsion, or image-producing, part of the film, but to the base—the plastic surface on which the light-sensitive part of the film is attached. *Portrait* films have base and emulsion surfaces that readily accept retouching. As such, they are better films only for those commercial portraitists who participate in the dubious practice of making insecure clients look "better" than they do in real life.

Portraits can be made on any film used for general photography, as well as on a few special-purpose films. However, some films fit certain situations better than others. If you are using a small camera and have bright light conditions, buy the slowest film you can find. Agfapan Professional 25, Ilford Pan F (ISO/ASA 50), and Kodak Panatomic-X (ISO/ASA 32) are all excellent films for outdoor portraiture with small cameras. These three films are all available in 35mm and roll-film sizes.

A slow film allows you to use a wider aperture than a fast film does at any particular shutter speed. A wide aperture creates a shallow depth-of-field, throwing background objects out of focus. This creates a visual separation between the center of interest and the background. Photo: K. Tweedy-Holmes.

If you want to use smaller *f*-stops than would be possible with these films, or if you are shooting portraits outdoors on a partially cloudy day, use middle-speed films such as Ilford FP 4, Agfapan Professional 100, or Kodak Plus-X. Any of these will produce excellent, fine-grained negatives from which highly detailed prints can be made.

For environmental portraiture where your subject moves around a lot, for dull days outdoors, or for available-light portraits indoors, use a fast film such as Kodak Tri-X, Ilford HP 5, or Agfapan Professional 400. These are a little coarser-grained and not as high in resolution as the slower films, but are still capable of giving highly detailed negatives that can easily be enlarged to 10 diameters with good image quality.

For night portraits or for those times when you want graininess to be part of the picture, use super-high-speed films such as Kodak Recording Film, Royal X Pan, or Agfapan 1000. These films have far less tonal quality than their slower counterparts, but they do produce a "mood" that the others cannot.

Your choice of film depends on the lighting conditions you will be working under and on the way you want your prints to look. Another thing you should consider is the size of your final prints, especially if you use small cameras to make your portraits. Generally speaking, the less sensitive to light, or slower, the film is, the finer granularity it will have. Fine-grained films are better at resolving (rendering clearly) small details than coarse-grained films.

While human subjects may be counted on to stand still, animal subjects cannot. The easiest way to avoid blurred pictures is to load your camera with a fast film and select a high shutter speed. Photo: K. Tweedy-Holmes.

Color Films

The various color films, like the black-and-white ones, come in different speeds, render fine detail to greater or lesser degrees, and have different enlargement potential. They also give you two more things to worry about: what their color temperature balance is and whether they have direct-positive or negative emulsions.

Color negative films work the way black-and-white films do—they produce a negative image which is used to make prints. And, just as with black-and-white films, the slower the color emulsion is, the less granularity, the better resolution of small details, and the greater enlargement potential there will be.

Direct-positive color films are primarily intended for projection as slides. With these, the speed of the film affects not only the granularity, the acceptable degree of enlargement by projection, and so on; the speed of color transparency films relates to color saturation as well. The slower a color transparency film is, the more saturated the colors it produces will be. Since prints can also be made from this kind of film, it presents no serious limitations for portraiture.

Color accent and a kind of soft spotlighting will emphasize the subject in a subdued setting. Photo: M. Janeczek.

Because color films respond to both the colors and the intensity of the image-forming light, they are made to perform accurately within a certain color temperature range. Color temperature has nothing to do with the weather; it relates to the relative amounts of blue, red, and green wavelengths in the light falling on the subject. Sunlight at noon, for example, is extremely high in blue content. Films marked *Daylight* are designed to be used outdoors, or with electronic flash units, which have a light output similar to that of the sun. Tungsten films are made for use with photographic lamps that give off far more red than the sun does.

Most color negative films are easily used in daylight and in tungsten, or other indoor, light. When prints are made, filters in the enlarger can compensate for the different kinds of light the color negative film has been exposed to.

Color transparency films are balanced either for daylight or tungsten light. If you use tungsten-balanced film outdoors, your transparencies will come out too blue. If you use daylight film indoors, the film will make everything look reddish. Choosing the wrong film for your portraits could ruin the color rendition of an otherwise fine portrait.

Normally, incandescent house lights have a higher red output than tungsten photo lamps do. If you are making available-light portraits in color, substitute photo bulbs for the house lights, or check the wattage of the house lights and use the filters recommended in the accompanying table.

Filters and Exposure Adjustments for use with Incandescent Light and Tungsten Film

Wattage	Filter Exposure
75-watt bulb	82C filter + ⅔-stop exposure increase
100-watt bulb	82B filter + ⅔-stop exposure increase
200-watt bulb	82A filter + ⅓-stop exposure increase

The filters recommended in the chart are for tungsten film. Do not try to use color daylight film indoors, unless you have an electronic flash unit. The filters required for correction and the increase in exposure necessary because of the filters would make your exposures so long that your subject would never sit still for them.

If you get stuck outdoors around noon with color tungsten film, use an 85B filter and increase your exposure by ⅔-stop. Earlier or later in the day, use an 81+81EF filter, and increase your exposure by 1 stop.

These filters and adjustments in exposure will bring you closer to the actual colors, but they are no substitute for using the right films at the right time.

3

Natural-Light Portraits

The easiest and most immediately rewarding way to make portraits is to do them in natural light. You will not have to worry about setting up lamps, determining correct lighting ratios, or wondering if your flash unit is recharging properly. Simply pick a suitable day, load your camera, and take your subject to an outdoor location that provides pleasant surroundings in which to make a portrait.

The location you pick, the time of day, and the weather will all affect the look of your portrait. The last two considerations are mostly technical ones and can be handled easily if you choose your film and equipment to suit the day. The first consideration should be approached from a psychological standpoint. How will the location affect your subject? Does it have any relation to your subject? Did he or she have any say in choosing the location? It makes little sense to take your subject to a locale that has nothing to do with his or her life; such a place would add nothing to your understanding of the subject. A badly chosen spot will also confuse the viewer of the portrait.

Before taking your subject for a walk in the noonday sun, consider his or her features. Does he or she have deep eyes that will all but disappear in the harsh, overhead light that occurs around noon? Imagine your subject outdoors. What time of day is it in your mental picture? If it is early morning or late afternoon, arrange to photograph your subject at one of those times. Is it a pearly, cloudy day? Wait until the weather in your mental image actually occurs and you will be one step closer to portraying your subject in a way that shows how you feel about him or her.

Soft natural sidelighting avoids confusing shadows when your subject is close to the background. A normal or even a moderate wide-angle lens is excellent for full-figure portraits, especially when you want to include some of the surroundings. Photo: B. Krist.

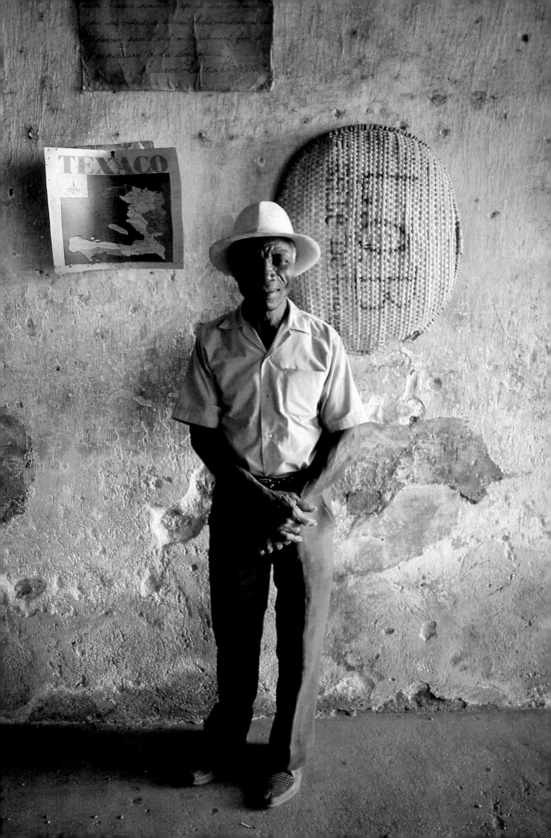

Choosing Your Location

Make the portrait session a cooperative venture. Let your subject choose an outdoor location; this will show that you are interested in recording more than just his or her physical appearance. It will also give your sitter some control over the outcome of the picture, making the prospect of being photographed a more appealing one.

Find out if your subject has a favorite park bench, outdoor restaurant, or other locale with special significance. People will be more responsive in familiar surroundings.

If your sitter has no preference and would rather have you choose the location, find a place that relates to your perception of the person. A graphic surrounding with distinct shapes might help portray a subject who is very precise and possesses a strong character. In such a case, use a long-focal-length lens, whose compressed perspective will appear to bring the background closer to the subject. By choosing large or small apertures, you can control the relative sharpness of the picture background. The long-focal-length lens will also help you avoid getting unwanted people or matter in your picture.

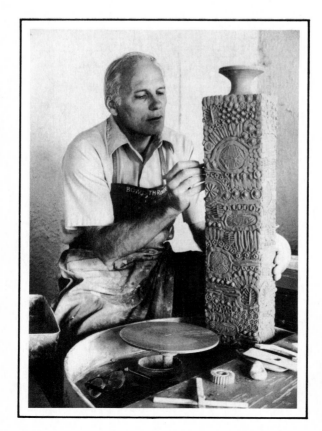

Even in a location with a light source you cannot move, such as the sun, you may have some control over the way the light strikes the subject. When texture is important, position important objects so that the light hits them obliquely. Photo: A. Rakoczy.

Surrounding the main interest with contrasting textures often adds emphasis to the subject. Here the young woman's smooth skin is accentuated by the rough, unfinished wood. Photo: J. Alexander.

When choosing a location in general, avoid grandiose or dramatic locations such as monuments or entrances to historic buildings; the importance of these structures will usually compete with your subject for attention in the picture.

If you are making an environmental portrait of someone who works outdoors, choose elements of the surroundings that best illustrate what your subject does, and how. You should not only pay attention to the work itself, the tools, and the overall location, but also be aware of how the light falls, where shadows are cast, and what, if any, distracting elements you can work around or remove from the scene. For example, a full-figure shot of a cabdriver standing by his or her vehicle, or of a porter near an open door, might be ruined by a stray piece of paper drifting into the foreground of the picture.

Use direct sunlight from an angle to reveal the modeling of a subject's head. When possible, lighten the harsh shadows a bit by reflecting some of the light back onto the subject's face. Any piece of white paper or cloth will do nicely. Photo: C. Child.

Direct Sunlight

Direct sunlight is both a blessing and a curse for portrait making. It provides enough light for you to use motion-stopping shutter speeds even with the slowest films, and allows you a choice of apertures with which to establish just the right amount of sharply rendered foreground and background. However, direct sunlight is also seductive and may get you so excited about the potential portrait that you make pictures without recognizing what the light is doing to the sitter's features.

Shadows cast in direct sunlight will usually record more distinctly on film than they appear to your eyes. This is because your perception of what your eyes are exposed to is constantly adjusted by your brain. Normally, we do not look consciously at shadows, concentrating instead on the objects that cast them. You should make a conscious effort to observe the intensity and the color of shadows falling on your subject.

Noon sunlight is generally the worst for making pictures of people, including portraits. The sun is almost directly overhead, casting strong, dark shadows directly under your subject's chin and in the eye sockets. The highlights of pictures made at noon are harsh and intense if the rest of the scene is exposed "correctly". There will be very little modeling, or three-dimensionality, of the subject's features if he or she is posing conventionally (standing or sitting perpendicular to the ground).

Technique Tip: Reflectors and Natural Light

Use a reflector to overcome the problems often presented by direct sunlight. You can buy two-sided white/silver or silver/-gold reflectors, but any white card about 38 × 51cm (15" × 20") or larger will do equally well. You can also improvise with a white shirt or sweater, a sheet of newspaper, or even an open magazine. Place the reflector just out of camera range, in a position to catch the sun and direct it onto the subject for any of the following:

1. Lighten the darkest shadows.
2. Wash out color casts on the subject's face from clothing or surroundings.
3. Provide frontal light, with the sun behind the subject as a back light. (This is especially good to eliminate subject squinting, and to avoid excessive contrast in color pictures.)
4. Add extra light on a subject in open shade.

It is far easier to work in morning and afternoon light. The sunlight is not as harsh as at midday, so your subject will be less likely to squint, and the shallower angle of the sun will give more dimensionality to your sitter's features. Shadows will often be softer, and there will be less overall contrast in the scene. The shadows cast will still be quite distinct, though; use them to define your subject's features. Be careful of *hose shadows*—long, dark areas on a subject's face caused by his or her nose blocking light reflected from another part of the face. Since you cannot move the sun, ask your subject to move his or her head slightly until one of two things occurs: either the shadow assumes an appealing, natural shape or it blends with the darker parts of the face, causing a Rembrandt-like triangle of light on the side of the face away from the sun. If you ask your subject to turn more into the sunlight, the nose shadow will disappear eventually, but at the expense of dimensionality, since most of the face will be illuminated to the same degree.

Using direct sunlight at different times of the day will change not only your subject's appearance, but that of the surrounding areas as well. Morning light will give the background a rosy quality, making the scene softer- and gentler-looking than it would in the middle of the day; evening light gives things a more red, mauve, or orange look, which adds strength to color portraits that include a lot of background.

Open-Shade Illumination

Open-shade illumination—the light coming from a cloudless blue sky, or that in a shaded area illuminated by skylight—is far more even and gentle to facial features than direct sunlight is. While direct sunlight is specific, intense illumination, much like that from a gigantic spotlight, open-shade illumination is more diffuse. Shadows are less prominent, with far softer edges, and facial features maintain good modeling. Open-shade lighting is not unlike the skylight illumination used in portrait studios; it is the most trouble-free light available for most kinds of portraiture.

Since shadows in this kind of light are not much of a problem, and since there usually is plenty of light intensity, you can concentrate on positioning and relaxing your subject without worrying about dark eye sockets, harsh highlights, or squinting.

Much of the time the intensity of open-shade light will not be much less than that of direct sunlight; you will be able to gain the image quality of fine-grained, slow films without having the blocked-up excessively dense highlights that can occur in direct sun.

The mood of color portraits made in open shade can be controlled to some degree by exposure. Slight overexposure ($\frac{1}{3}$- to $\frac{1}{2}$-stop) will

There may be a few moments in photographing six boys when all have appropriate poses. The light in open shade eliminates the problem of shadow-obscured faces. Photo: C. Child

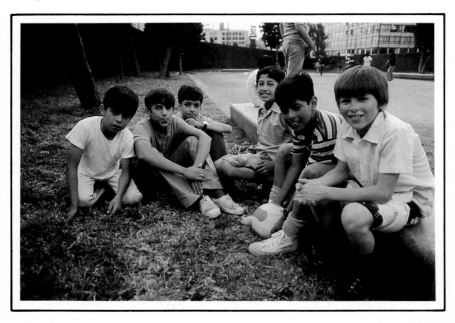

46

give a lighter, more pastel quality to the colors of the subject and the surround, while the same degree of underexposure will deepen hues and make the overall picture more vibrant. *Bracket* your color-transparency exposures by making a first exposure at the meter-indicated reading, a second exposure ⅓-stop above that reading, and a third exposure ⅓-stop below it.

Open shade does have one disadvantage. Since the light source is sunlight reflected from the sky, and since the sky reflects blue, the light reaching your subject will be bluish as well. In black-and-white photography, this makes no practical difference—black-and-white films respond more to the intensity of the light than to anything else. With color films, though, the results might be too cool for your taste, especially if your sitter is extremely fair-skinned, blond, or both. If your subject is wearing cool colors, and you are shooting against greenery or some other cool-toned background, the problem is compounded. A skylight 1B filter will warm up your image sufficiently in most situations, but if you think the problem is extreme, use a redder filter such as the 85C. Both of these require ⅓-stop more exposure than you would need without a filter.

Technique Tip: Sky As Portrait Background

The open sky can make an effective background for a color-transparency portrait. Frame the picture so that only the blue sky is seen around your subject. Place a polarizing filter over the lens and turn it until the sky appears at its darkest. The maximum effect will occur with the sun 90 degrees to the right or left of the subject. Use a reflector to fill in the dark side if necessary.

Make the exposure based on a through-the-lens meter reading with the filter in place. The sky will be rendered a deep blue, while your sitter's skin tones will be properly exposed.

Make additional exposures at one-half stop more and less than the first exposure. These variations may have expressive qualities that are particularly effective.

If your camera does not have through-the-lens viewing or metering, look through the polarizer and rotate it until the sky is darkest, then mount it on the lens in the same orientation. Take an unfiltered meter reading directly from the subject's face, and increase the suggested exposure by one stop.

Cloudy Days and Bad Weather

Overcast. The light that falls on cloudy, overcast days is extremely diffuse, with little or no apparent direction. Shadows are extremely soft, and may not be noticeable at all. The overall contrast of the light is low, and to the untrained eye it may seem too dull and lifeless to use for picture making. For this reason, few beginning photographers shoot on overcast days; this is a pity because marvelous images can be produced in overcast lighting.

Choose your color film based on the *degree* of mood you want to create. Fast color films will allow you to make hand-held portraits, but will give less color saturation and more grain. These seeming deficiencies might improve the picture by creating a romantic, textural quality. If you want less impressionistic results, use a slow color transparency film, such as Kodachrome 25, and mount your camera on a tripod or other means of support. Slower color films will give richer colors and less of an airy quality, although the tones will remain muted enough to flow into one another.

Black-and-white portraiture in overcast conditions will usually produce images low in contrast, especially if fast films are used. All colors close to one another in intensity will reproduce more or less the same shade of gray, and there might not be enough separation of tones. To overcome this, shoot with the slowest film you can (slow films are

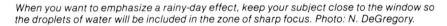

When you want to emphasize a rainy-day effect, keep your subject close to the window so the droplets of water will be included in the zone of sharp focus. Photo: N. DeGregory.

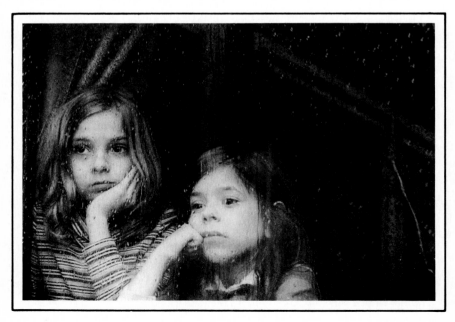

more able to separate tones) or use a No. 11 yellow-green filter to increase contrast without appreciably lightening your subject's skin tones). A No. 8 medium-yellow filter can also be used, but rendition of light-toned skin may suffer.

Bad Weather. Fog, mist, rain, and snow are all useful to the portrait photographer with an adventurous subject. Fog and mist both render backgrounds in a ghostly, almost dreamlike fashion that works equally well in color or in black and white.

The farther you are from your subject, the more fog or mist will soften the appearance of his or her features. Use a long-focal-length lens up close when the subject has sharp facial features and the background is totally diffused. Step farther away and use a standard lens for an equally soft rendition of subject and surround. Bright colors photographed in the fog take on the appearance of watercolor washes, flowing into one another with no distinct separation. If you are photographing a subject in flowing clothes, you might be able to make the background and clothing intermingle. Shoot with a long lens from a distance, using the widest aperture available and focusing very carefully on your sitter's face; a slight breeze will do the rest.

Do not use any filters when shooting in fog or mist. The light is so diffuse that sharpness is at a minimum already, and added filters will make sharp images even harder to produce.

Look for simple solutions to portrait problems. Asking the subject to tilt her umbrella backward allowed more light to strike her face and simultaneously created an effective background. Photo: J. Alexander.

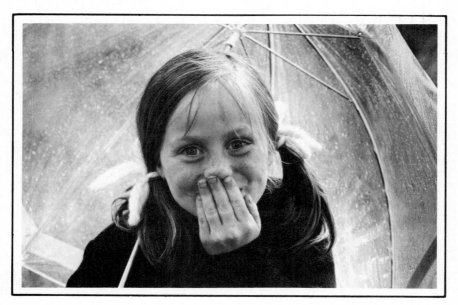

4

Lighting

Portrait lighting equipment need not be specially bought, nor complicated. As a rule, the fewer lights you use, the more effective your portrait will be, provided you use them effectively.

Most portraits need no more than one light. Shadow areas can be filled in with a reflector, and the light itself can be "spread around" or diffused with tissue, translucent plastic, or mesh screens. When making black-and-white portraits, you need not be concerned with the color balance of the light used; you can use room light, light from a desk lamp, even candlelight to create a particular effect. The simplest lighting to use, and oftentimes the most effective, is built into any room with an unobstructed window. Window light has probably supplied the illumination for more indoor portraits, photographic and painted, than any other kind of lighting. Using window light is ridiculously simple. Position your subject near the window, use daylight-balanced color film (or black-and-white film), ask your subject to move his or her head until you see the modeling you want, and make your picture. A large white reflector held some distance from the shadow side of your subject's face will provide the necessary fill-in lighting. That is all there is to it. You can concentrate on the subject's expression and feelings instead of worrying about the lighting setup. However, you might not want to build an extensive collection of portraits all made near the same window. If you decide to use artificial lighting, keep everything as simple as possible. No matter how many lights you use, you must give the impression that most of the illumination is coming from one direction. Nothing looks more amateurish than a portrait with intersecting shadows caused by evenly intense lighting coming from two or three different directions.

The simplicity and directness of window light is complemented by a plain background. You can eliminate an indoor background simply by not lighting the area. Photo: K. Tweedy-Holmes.

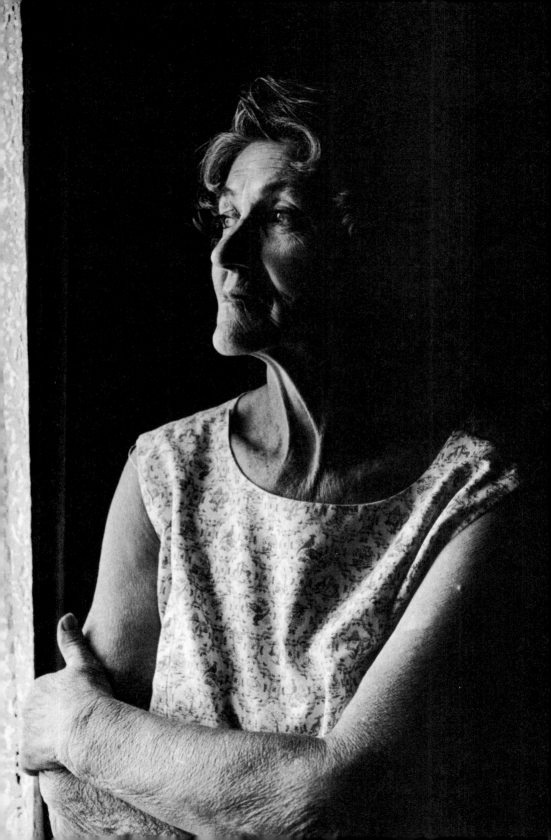

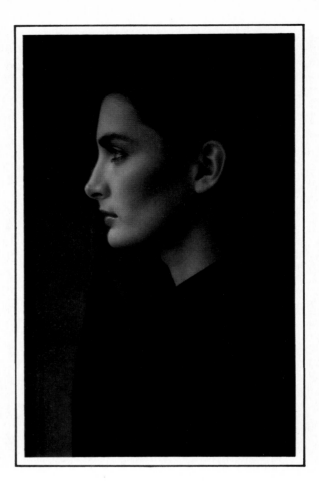

You can achieve emphasis even with very soft, low-intensity light by using a background and costumes that contrast with the skin tone. Subtle use of make-up adds to the effect in this picture. Photo: R. Farber.

Light Direction and Intensity

The direction and size of a light affect a portrait at least as much as the intensity of the light does. Small, directed lights create clearly defined shadows and a large distance between the highlights and darker portions of the subject's features. The farther off to the side of your subject the light is, the more elongated the shadows will be. If the light is too high or too low to reach into the shadow areas of your subject's face, you will get results not unlike those produced by noon sunlight—harsh highlights and dark eye sockets. The closer the light is to your camera, the more evenly it will fall on your subject; the larger and more diffuse it is, the more gently it will model your sitter's features, leaving shadow areas less well-defined.

Before you start to add lights, establish the position, the intensity, and the direction of your main, or key, light. It might be all you need, along with a reflector. Any lights you decide to add should be considered substitutes for the reflector—they should aid the key light, not compete with it.

Technique Tip: Practicing Portrait Lighting

The way to master portrait lighting is to try various set-ups, make mistakes, and learn from the mistakes. No book can give you the kind of knowledge that firsthand experience will.

Use a dummy head as a practice subject: a styrofoam wig stand, a full-head Hallowe'en mask (not too grotesque), or an inexpensive plastic or plaster bust.

Set up the dummy and make an experimental series of pictures using only one light, a key light. Keep notes on the distance, angle, and height of the light, and the exposure. Also note the kind of reflector around the lamp, its size and degree of shininess.

Start with the key light pointed at the subject directly from the camera position, at lens height. Then shift it higher, and lower. Next, move it to positions successively farther to each side: 30 degrees off the lens-to-subject axis, then 45 degrees, 60 degrees, and finally 90 degrees to each side. Again make exposures with the light at various heights in each position.

Keep prints of these exposures in a logbook, along with your notes. If you use an instant print camera, you will see your results immediately at each step.

Make another series of pictures with a second, fill-in light on the opposite side of the camera from the key light. Keep the fill light farther away, or use a less intense light; use the set-ups discussed in this chapter and elsewhere in the book. Make notes as before, and keep the results in the logbook.

Only one rule of photographic lighting makes sense: It should always be convincing. The purpose of your portrait should be to convince your viewers that the portrait is an accurate representation of the subject; the portrait should not be a showcase of your lighting virtuosity. No matter how cleverly you have arranged the lights, if a viewer notices their effect before noticing the person being portrayed, you have failed.

Single-Light Portraiture

Look through your collection of pictures made outdoors, and pick out those of people: single subjects, pairs, or groups. Separate those made in bright, noonday sunlight; then make another pile of those made in bright, early-morning or late-afternoon sunlight. Make a third pile of those made in open shade or on overcast days. What can you tell from them?

What does all this have to do with single-light portraiture? Well, the sun is a single light source that treats subjects in the same way a single light used indoors does. The higher either is in relation to the subject, the less likely it is that recesses in the face will be properly illuminated; the more diffused these light sources are, the more gentle the transition of the subject's features from light to dark will be.

Flat Lighting. Keep this in mind as you set up lighting indoors: If you want smooth lighting with just a touch of modeling, place a large lamp with a big reflector near the camera position. As you get ready to photograph, have your subject look into the camera, and check the light *through your camera's viewfinder* (looking at your subject from above the camera might not show you exactly how the light will look in the picture). Watch for shadows cast by your subject on the background. If the shadows are too strong, move your subject forward so the shadow will recede. If the shadow makes a pattern above your subject's head, the light is too low—raise it, and the size of the shadow will diminish. Moving the lamp to the right will cause shadows to extend to the left (looking at your subject), and vice versa.

When photographing with dramatic light, take a meter reading only from the areas of your subject you want to be properly exposed. This is true even if those areas are only a small part of the total picture, as is the case here. Photo: J. Howard/Positive Images.

Dramatic Lighting. For graphically strong, dramatically lit portraits, set up a light at 90 degrees to your subject, and use a dark background. This will give your subject's face a half-moon effect, illuminating one side of the face while leaving the other side in complete shadow. This effect works best with people who have extremely strong facial features. If you want a little light on the shadow side, use a reflector to pick up and throw back some of the light coming across your subject.

Pictures work best when the subject's pose and the lighting style complement each other. Here the dramatic pose goes well with the strong sidelight. Photo: A. Balsys.

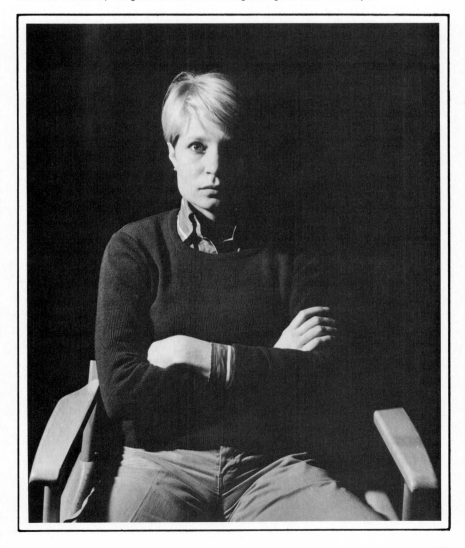

Conventional Lighting Techniques

For more conventional pictures, place the light at about 45 degrees to your subject, and elevate it to just above his or her eye level. Use a reflector panel on the less-lit side to soften the shadow, and have your subject move his or her head slightly to the left or the right, until the nose shadow joins with the one cast by the cheek to form a triangle of light on the dark-side eye.

If your light is direct, with no diffusion, you will find that any movement by the sitter may ruin the lighting effect. Placing a piece of diffusing material over the light will allow more flexibility—the shadows cast will be subtle enough to let your subject move his or her head relatively freely without causing lighting problems.

Many professional portrait photographers use a light bank—an extremely powerful, broad-based series of lights (electronic flash or tungsten) placed together under a large diffusing screen to give illumination that is even, soft, and strong. Making a light bank can be expensive, but for a few dollars you can have the next best thing. Buy a few A-clamps or accessory clips from your hardware store or camera dealer. Use these to hold a large white card at an angle over your lamp. Use

To provide an intense but soft light for his portrait, this photographer used five separate flash heads, bouncing each into a large studio umbrella. The umbrellas have white reflective surfaces on their insides.

the biggest bulb that your lamp can hold, and tilt the reflector cards in the direction of your subject. To lessen the chances of fire, use heavy cardboard and check it for overheating.

Another way to broaden the base of your light is to bounce it off a reflective umbrella. If your subject has highly textured skin and you want to lessen the texture, use the light frontally, from the camera position. The greater the angle of the light is, the more texture will be noticeable.

You can use the single-light method to produce silhouette effects. Place the lamp behind your subject, aiming it at the background (a light background is usually most effective). Make your light reading from the background, not from the subject. Your sitter will be rendered extremely dark.

This technique works well only if your subject has a characteristic posture that can stand to be recorded at the expense of all other visual information. If you know someone with as expressive a body as Charlie Chaplin, Winston Churchill, or W.C. Fields had, this kind of portrait will show it off well.

For a more theatrical look, you can give the silhouette a halo. Place the light behind your subject, as before, but this time point it at your subject's back. This will cause a rim of light to spill around your sitter's body.

Bounced light produces no harsh shadows and gives gentle modeling to subject features. In this informal portrait, a flash bounced into a large white umbrella produced illumination that looks similar to diffuse daylight. Photo: J. Alexander.

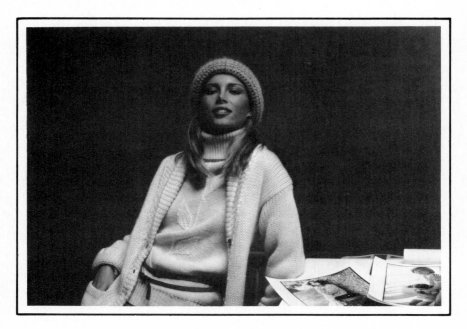

Key and Fill Lighting

You may have found that one lamp with a reflector on the opposite side makes some subjects look well lit to the eye, but produces photographs that are too contrasty. This is because your eyes compensate for the difference in light and shade more than film does. An easy way to overcome this problem is to substitute another lamp for the reflector.

If you place the second lamp the same distance from your sitter as the first, you will get even, flat-looking illumination—provided both lamps are of the same intensity. If you want better modeling of your subject's features, the second, or fill, lamp should be farther away than the main, or key, lamp. Another solution is to use a fill lamp that is less intense than the key lamp. How far away, or how much less intense, depends on the kind of portrait you are trying to make.

Lighting Ratio. For the most natural-looking results, set up your lights so that there is a 1½- to 2-stop difference between them. Place your main light where you need it, then position the fill lamp so that it fills in the shadows to your satisfaction. With both lamps on, place a gray or white card in the sitter's place, and make a reflected-light measurement with your camera's exposure meter. Make a note of the exposure indications. Turn off the key lamp, leaving the shadow fill light on, and make another light measurement of the card. If the fill light gives you 1½ to 2 stops less light than the two lamps combined, you will get pleasing results with black-and-white or color film. If the difference in light intensity is less than 1½ stops, move the fill light back a little, and make light readings again, adjusting the fill light until the difference between the key-fill lights and the fill-only light is about 1½ stops.

You may also use an incident-light exposure meter. This type of meter has a white sphere over the light-measuring cell and measures the light falling on the subject. It is used from the subject position and is pointed at the camera. With such a meter, you do not need the gray or white card to measure the light. Instead, turn on the key light *only*, measure the light it throws onto your subject, then turn it off, turn on the fill light, and measure the latter *only*. Make sure the light-collecting sphere of the incident-light exposure meter is pointed at the camera, not at your subject.

To emphasize large, expressive eyes have your subject tilt her head downward and look up toward the camera. Use soft, full frontal lighting. Photo: J. Kalikow.

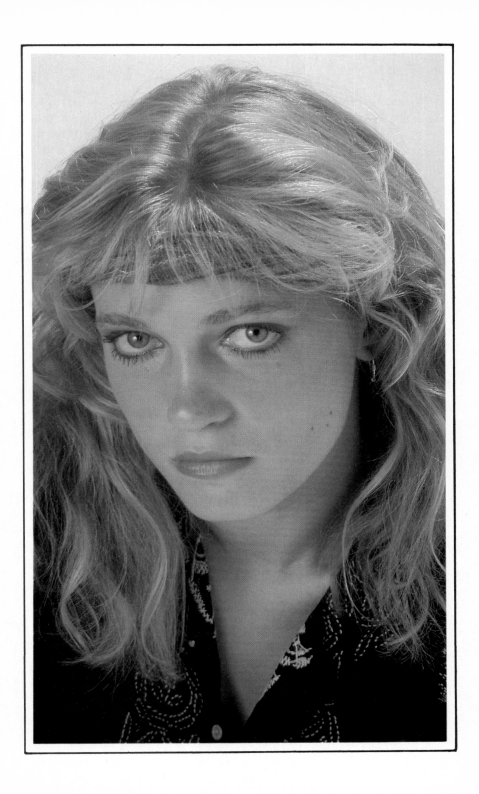

Highlights and Shadows

Varying the Lighting Combinations. For more dramatic separation of light and shade, make the distance between the lights greater, use a more intense key light and/or a less-intense fill light; but watch the shadows carefully, so that they fall in the right places. Pay careful attention to the way your subject's nose and eyes look, and remember that anything you see will be exaggerated on film. Look at your subject through one eye to get a better idea of what the lens will see.

For less separation of light and dark tones, move the fill light closer to your subject, or use a more intense fill light, visually checking as you do.

Once you have set up the key and fill lights for the effect you want, you will have to keep the distance between them and your subject more or less the same. If you must move your subject forward or backward any appreciable distance, say a foot or so, you will have to move the lights the same distance, or the lighting effect will be changed slightly (in some cases, only the exposure will be affected).

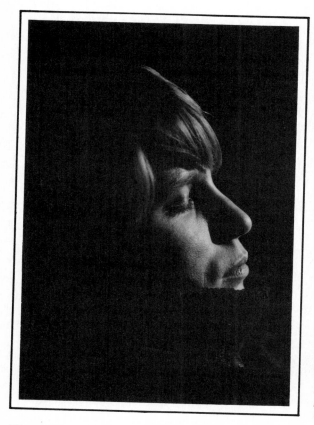

Have the subject relax while you make fine lighting adjustments. Keep an open mind about the best pose, maybe a relaxed one is a picture in itself.
Photo: A. Balsys.

There is no law that says your portraits must have detail in both highlight and shadow areas. If you want an extremely dramatic portrait, make the intensity difference of key and fill lights greater than 3 or 4 stops. Just be sure that your subject's appearance and expression work with, not against, the lighting you choose.

Technique Tip: Quick Light Set-Ups

It is tiring and boring for a subject to wait while you set up and shift lights, check and adjust their balance, recheck and readjust. Keep this kind of delay to a minimum by establishing some basic data and working in the following way.

1. In a practice session, determine the key and fill light positions for specific lighting ratios (2:1, 3:1, etc.). Measure and note down the light-to-subject distances for each ratio.

2. When you make an actual set-up (ahead of time, if possible), use the same lights. Place the key light first, at whatever working distance will give you a desired exposure, degree of coverage, or lighting effect. If you want to photograph at f/5.6, for example, it takes only a moment to move the key light back and forth and take meter readings to find the required working distance.

3. Consult your notes for the desired ratio. Determine *how many times* closer or farther away the working key light is set up than the distance recorded in your notes. If the practice distance was 5 feet and the working distance is 7½ feet, it is 1½ times farther away. To get the required ratio, place the fill light at the same multiple (1½ ×) of its recorded practice distance. If your notes show the fill was at 9 feet, place it at 13½ feet in the actual set up (9 × 1½ = 13½).

4. Use the same procedure when you shift lights during a portrait session if you want to maintain the same ratio. If you move the key to two-thirds of its original distance (for a stronger effect, or to use a smaller f-stop), also move the fill to two-thirds of its original distance.

"Glamour" Lighting

Portrait lighting schemes that involve more than two lamps are usually most useful when you want to accentuate certain physical characteristics of your subject. If, for example, you are making a portrait of a woman with beautifully full, richly colored hair, you might want to light the hair itself, as well as the entire scene. If your sitter has especially luminous skin, ordinary key-fill lighting may not do it justice.

General Considerations. Lighting which enhances physical beauty, "glamour" lighting, is not difficult to arrange effectively as long as you check the result of each light as you add it. There are no set rules for "correct" lighting arrangements—each person you photograph will require a slightly different approach. But there are some things to keep in mind.

Because you will be most concerned with your sitter's expression and physical appearance, you will make it easier on yourself by approaching the shooting as if it were a formal portrait session. Keep the background as simple as possible. If you are making color portraits, make sure that the background color does not clash with or overpower the tones of your subject's skin and clothing. Seamless paper is ideal, although a large piece of smooth fabric without too much noticeable texture will work just as well.

Most pictures of this type are head-and-shoulders or full-face portraits, so arrange your lights for those parts of your sitter's body. Establish your key, or main, light as you did in the other lighting schemes, making sure that it covers the desired area evenly. Now decide what parts of your subject need accenting—these will determine how you set up the fill light and other lights.

If you are shooting in black and white, or if you have the proper filter gels to balance your tungsten lights for daylight use, you might try to place your subject near a window, a skylight, or another natural-light source. The natural light will most probably be more diffuse than any other source you have, in which case it will work well as a fill light.

Do not be afraid to experiment with different positions and combinations of lamps—just keep in mind that, for most pictures, the light should appear to come mainly from one direction, and that all additional sources should make you feel the effect they create, rather than pointing up that other lights have been used.

Hairlights. There are two ways to show off your sitter's hair. Set up a small flood lamp or spotlight over your sitter's head, so that the hair and shoulders are lit from above, then place a fill light on the other side of your sitter from the key light. Or, place your subject rather close to the background and set up a flood lamp on the floor behind your subject, aimed at the background itself. If you aim the light properly,

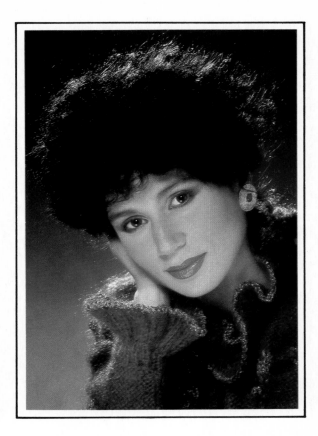

When you want your subject to hold a position just so, it helps to get some sort of support into the pose—the arm and hand in this picture. Photo: V. Podesser.

it will bounce off the background onto the sitter's head and shoulders. Be careful with this second method if you are shooting in color—the color of the background will affect the color of the light reflected from the background to the subject. This method, like the first, will probably require the use of an additional fill lamp to even out the shadows on the darker side of the subject.

In any event, check the shadows cast and the overall effect of each lamp as you turn it on, and do not add others until you are satisfied with the position of the one with which you are working. If you try to set up three or more lights without checking each as you add it, you will have a devil of a time trying to eliminate cross shadows, unwanted overlapping, or other problems that might occur.

Accentuating Facial Structure. Spotlights, with their narrow angle of illumination, are ideal for lighting up small areas of your subject's face—the cheekbones, the eyes, the muscles in the neck—but they must be used carefully, so that they blend in with the overall lighting. If you can see the boundary of illumination while using a spotlight, chances are that your photograph will show it far more clearly; in such cases, it may ruin your picture.

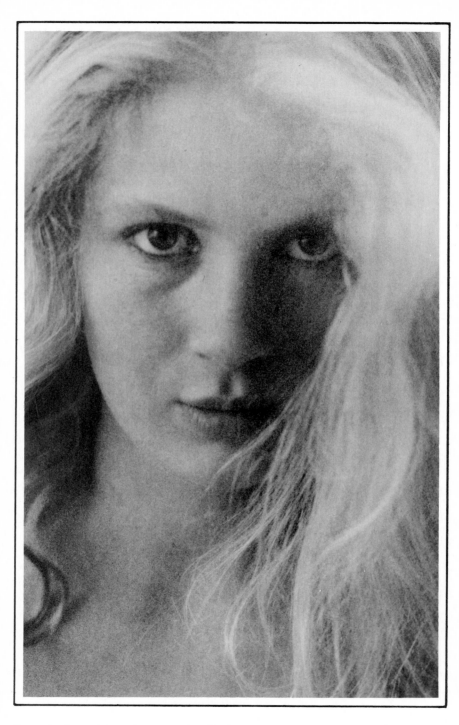

To emphasize graininess for expressive effect in a print, keep the subject's image size small on the negative so you can enlarge it—and the grain—much more than normal. *Photo: P. A. Eastway*

Other Schemes

Besides giving a "natural" appearance, or accenting the physical attributes of the sitter, lights can be arranged and adapted to create specific moods—moods that you feel will best convey the character of your sitter, or your interpretation of his or her personality.

The mood of your lighting depends as much on the background you shoot against, the film you use, and the sharpness and focal length of your lenses, as it does on the lighting itself. All these things should be chosen with a specific aim in mind.

Creating a Soft Effect. If you want a soft, airy photograph, the graininess of fast films may be useful. The background and your sitter's clothing will be most effective if they are light in color and if the colors blend rather than clash. The lighting itself should be even and broad, covering the whole picture area.

You can achieve a soft mood easily by placing your sitter near a window and using the light coming through it as background. A lace or gauze curtain over the window will diffuse and soften the light. Illuminate your sitter from the front with a large, diffused lamp positioned above your camera position, pointing down from slightly higher than your subject's head. For less directed light, use two diffused flood lamps of the same strength—or two flash units with diffusion grids on them—one from either side of your camera. Base your exposure on the lighting from the front, ignoring the window light—just as you would in a backlit situation outdoors.

Whenever you use two lights from the front, make sure that your subject's face does not show cross shadows—adjust the lamps so that the shadows they cast eliminate one another. With proper diffusion of the lamps, the shadows will be very soft and hard to see, but check closely, anyway, to make sure that they do not create unpleasant shapes under your sitter's nose or eyes. If your sitter has especially angular features, the shadow problem will be more likely to occur. Move the lights far enough back, or diffuse them enough, that the shadows blend into one another or disappear entirely.

Accentuating Texture. If your subject has highly textured or wrinkled skin, and his or her portrait will work better if you use the facial texture to its fullest, select a dark background against which the subject's face will stand out. Or find a location where the texture of the surround will complement that of your subject's skin. If you are shooting indoors, try using a piece of rough canvas, burlap, or raw silk instead of seamless paper, but keep the background featureless otherwise. Patterned backgrounds—wallpaper with little designs on it and the like—will rarely help your photograph.

Direct, undiffused lighting from a sharp angle will bring out the texture of your subject's skin best. If you shoot with slow, inherently contrasty films and use sharp lenses stopped down, the texture will come across even better.

Special Lighting Effects

Unusual Effects. You do not have to restrict yourself to straight daylight, tungsten, or flash illumination for your portraits. Sometimes quite inventive pictures are produced from unexpected light sources. For example, the light from a slide projector can be used to create dramatic portraits, with your subject framed in the light, the light itself framed by the dark outlines of the rest of your picture. You can make the same kind of photograph by placing your subject in a darkened hallway, framed by a shaft of light coming from an open door. You might also try making a portrait with light coming through a partially opened venetian blind at a time of day when shadows are long and deep. Take advantage of any light you see around you, and try to use it in a way that will help you portray your subject to the viewer.

You might try adding small lights or mirrors to more conventional lighting schemes so that small sections of your subject get more illumination. Jewelry, for example, can be given extra sparkle by your reflecting light from one of the lamps onto it with a small hand mirror. A small spotlight positioned near the camera will help you bring more attention to your sitter's hands; be careful to place it far enough away, or to use a bulb low enough in intensity, that the hands do not end up more illuminated than the more important aspects of the subject.

Bounce Lighting. You might find that some extremely active subjects—children, for example—are difficult to keep correctly situated within your lighted area. If you encounter this problem, change the lighting so that it all is bounced from the ceiling, the walls, or reflectors; your subject will then be free to move without casting unwanted shadows. Directionless lighting gives soft, airy-looking results; however, it does not work with all sitters. Try it with people who have smooth complexions, with children and babies, and any time you want to avoid all shadows.

If you plan to bounce tungsten or incandescent lighting, do your shootings in a room with white walls, and use powerful bulbs. Or, use one or two electronic flash units from the camera position, set up to bounce light from the ceiling to your subject. In a small, light-colored room, you will get the same effect with a bare-bulb electronic flash unit —one of these will give off light in a 360-degree circle of coverage, lighting your sitter from all sides. If you place the bare-bulb unit higher than your subject's head, any slight shadows will be well below the field of view of your lens. The exception is when you are making a full-figure portrait. For this you should simulate the bare-bulb effect, using a reflectorless tungsten or incandescent bulb, to see where the shadow will be located and how it will appear in the photograph.

Changing Background Color. If you are making your portraits in color and have illuminated the background, you can change its color by placing a tinted gel over the background light. Some of the light from this lamp will probably reach the back of your subject, so be careful to judge the color and its effect before you shoot. In many cases, the slight color change on your subject's back will be subtle enough not to become obtrusive; and since the background will have the same color cast, background and sitter will work together visually.

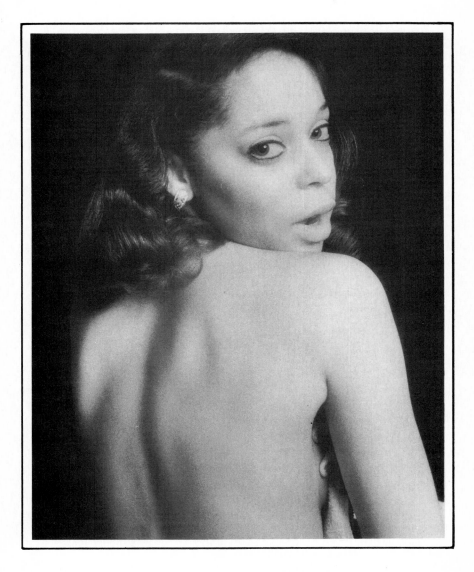

Keep in mind that the amount of illumination reaching the subject from a light source is lowered by one or more stops when the light is bounced. For this reason a fast film is frequently used with bounce lighting. Photo: D. O'Neill.

5

Artificial-Light Portraiture

The majority of us spend most of our lives indoors, under some sort of artificial lighting. You may therefore find more indoor locations where your sitter will be relaxed and cooperative. Try a place well known and comfortable to the sitter—his or her living room, for example. Such a location will offer another plus: The background will relate directly to the subject, lending more depth to your character study or informal portrait.

Black-and-white portraiture under artificial light is no more difficult than portraiture outdoors. The film responds to the amount of illumination, regardless of the light's color balance. All you need be concerned with are the proper exposure and the way the light falls on your sitter.

A light source placed close to the camera produces the flattest light—the one least likely to accentuate facial blemishes and therefore frequently the most flattering. Photo: S. Sullivan.

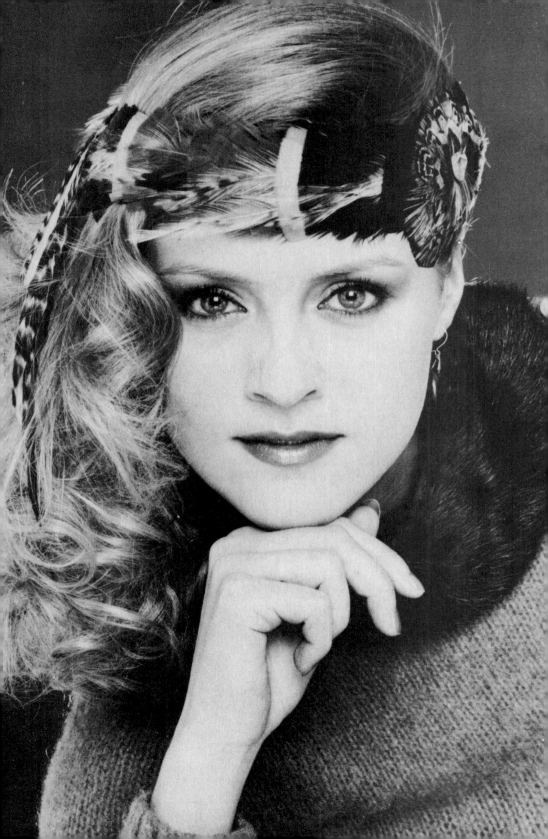

Color-Balancing Your Films

When you use color films, however, you must be careful to match the *character* of the light source with that of your film. If you use electronic flash, you will need daylight-balanced films, or tungsten films in combination with the proper filters over the camera lens or the flash unit. If you have tungsten film in your camera and are shooting available-light portraits in a room lit with ordinary household bulbs, you will need filters over the camera lens to lessen the red cast produced by incandescent bulbs. Sometimes this reddish cast adds a certain warmth to portraits; as long as your sitter is not wearing white (which would look pinkish or orange if lit by incandescent light), the facial features may look pleasant, even if you do not filter your light.

MATCHING TUNGSTEN LIGHT AND DAYLIGHT COLOR FILM			
Light Source:	Photolamp (3400K)	Tungsten (3200K)	Tungsten (Household)
Filter No:	80B	80A	80A + 82B

Fluorescent Lighting. Fluorescent lighting is another matter. Rarely has a pleasant-looking color portrait been made under fluorescent light without filtration. The illumination given off by fluorescent light makes skin tones look greenish or slightly magenta. Your sitter will look seasick. Even if you use filters to lessen the color cast, you will probably not get neutral-toned results. Avoid shooting under fluorescent lights if at all possible.

If, however, you have no choice—say you want to make an environmental portrait of someone who works under fluorescent lights—find out what type of fluorescent light is being used. There are six main types, each of which gives off a different type of light. These will give adequate results most of the time, as long as all the fluorescent lights are of the same type.

Changing the Light Source. Often you will be able to substitute tungsten bulbs for incandescent ones without affecting the look of the location. The overall illumination might be brighter, but if you change all the bulbs in the room, the proportion of light will remain the same, and the room will look natural—as will the skin tones of your subject, if you shoot with tungsten film.

If you prefer to use daylight-balanced film with flash, you can still produce the natural feeling of most rooms by placing specially designed slave flash units in the light fixtures. These are small electronic flash lamps with conventional, threaded bases, that will fire when the flash

unit attached to your camera does. In small rooms with light walls and overhead lighting, you can produce natural-looking light by simply bouncing the light from a reasonably powerful flash unit off the ceiling at about the same place the light fixture is located.

Total Lighting Control. In the studio or other permanent indoor portrait-shooting location, you can get total control over the lighting by adding reflectors, diffusing screens, and backgrounds to create a particular kind of portrait. If you plan to establish your own home studio, you must decide what kind of illumination to invest in. Generally speaking, tungsten lighting, with lamps, reflectors, light stands, and so on, will cost you less than an equivalent amount of studio flash equipment will. However, tungsten bulbs will usually require longer exposures, burn hot, and need replacing more often than flash lamps will. If you have a small space that is only semi-permanent, you might be able to do most of your portraits with a small, off-camera electronic flash unit such as those used by press photographers. One of these, a reflector, and a flash umbrella may be all you will ever need.

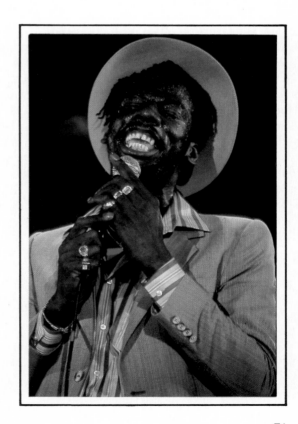

Theatrical lighting is usually spotlights with colored gels. You can easily reproduce that effect for portraits of performers. Photo: A. Chong.

Planning the Picture

Whether your portrait will be formal or informal, planning is equally important.

Studio Portraits. In a formal shooting area, where you have control over the space, the background, and the lighting, you will probably find portrait making easier if you plan your approach before you begin to shoot. Refer to your lighting diagrams and find two or three arrangements that you think might work best for the person whose portrait you are about to make. Since, in most cases, formal portraits rely heavily on your interpretation of the subject's features, decide whether you want to emphasize the skin tone or texture, whether the mood of the picture should be subtle or dramatic, and so on.

Think about the person, his or her size, demeanor, and so on; select a background that fits, and make a few mental or actual sketches of the intended pictures. Once you have done this, it will be easier to set up the lights quickly and change their arrangement should you want to. Get all your equipment—film, cameras, tripod, and so on—ready before the sitter enters the shooting area and use masking tape to mark off the boundaries within which your subject can move during the shooting. If you want to fill the camera frame with your subject, allow enough space at the top of the frame for the slight increase in height that will occur when your subject inhales or stretches. Few things are more frustrating than ending up with a fine portrait that is unexpectedly missing part of the head.

Measure the front-to-back distance of the scene, and select an aperture that will give you enough depth of field to insure that the front and back parts of your sitter are sharp. You can always open the aperture later for selective focusing, but it is reassuring to know where to set your camera to get everything in focus.

If you are using tungsten bulbs or quartz lamps, make sure that they are all functioning and are more or less the same age. Tungsten lamps get slightly redder as they burn, so it is best not to have any age disparity among them. If you are using flash, test the units before the session and keep a flood lamp in a reflector on hand to give you an idea of how the flash light will fall on your sitter.

Finally, keep all cords and wires out of walking paths and out of the picture area itself.

Having done all these things before the portrait session, you will have more time and energy to spend relaxing your subject and making the session pleasant for both of you.

Rules are meant to be broken, when done so purposefully. In general, a shadow like this on the background is a distraction. Here it adds a dramatic touch. Photo: V. Podesser.

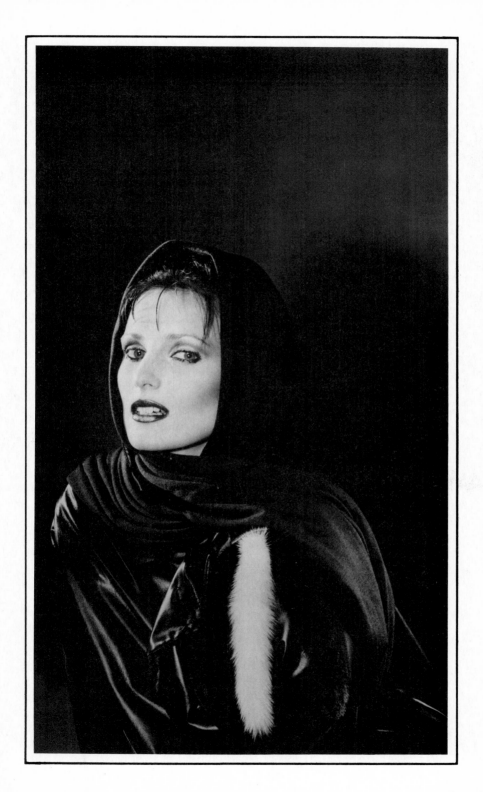

Checking Out the Surroundings

If you are about to make an indoor portrait of someone whose house you have access to before the shooting, bring along your camera, if it has a built-in exposure meter, or a hand-held meter. Make readings of the areas in which a good portrait is likely to be made. Most of the time, informal portraits will be most effective if you let your subject choose the location.

Examine the lighting in the most often used parts of the rooms you might be shooting in. If your subject has a favorite part of the sofa, check how the light falls on his or her face as he or she sits there. If the portrait will work better in the kitchen, den, or bedroom, examine the lighting there. Pay attention to the colors of the walls, to the design of the wallpaper, and to any reflecting surfaces that might become troublesome during the shooting. If you are going to shoot in color, see if the lampshades are large enough to accommodate tungsten bulbs without being burned. Examine the rooms for items that might be included in the picture to tell viewers more about the subject. If you know the subject well, or are dealing with an especially cooperative person, suggest the kind and color of clothing you think will work best —you might even get the person to have a change or two of clothes on hand to expand the scope of the session.

If you are going to make color portraits, pay close attention to the colors cast by objects in the location. A green wall hanging nearby

An easy way to light a large area evenly is to aim the light source toward a nearby wall or ceiling and bounce the light onto the scene. The farther the source is from the reflecting surface, the softer the light will be. Photo: B. Barnes.

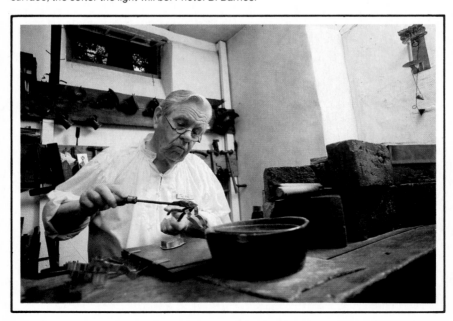

might affect the skin tones of your subject, for example. If the hanging is not going to be in the photograph, make a note to bring a piece of white cloth or cardboard with which to cover it and neutralize the color cast.

Look for more than one shooting area in each location, and prepare yourself to move your lights quickly if the need arises. Much of the time, you will be able to change your subject's location and the lighting by keeping the lights in the same place, but turning them on their stands to light up a different part of the room.

If you are shooting with flash, check the height and color of the ceilings, and make the appropriate camera settings. Bounced-flash illumination is easy to work with, especially with modern, automatic flash units.

Do a little "housekeeping" before the shooting—remove obtrusive objects from the scene, empty overflowing ashtrays, and rearrange wires, telephones, and other objects so that they do not command undue attention in the picture. Be especially careful of anything in your frame that can be read—there is generally no reason for a newspaper or a magazine to be so prominent in the photograph that your viewers are tempted to read it, rather than your sitter's face. Do not overdo it, though; removing all clutter from your subject's desk might remove an indication of his or her work habits. Make changes in the environment that will bring more attention to your subject, but do not radically change the surroundings.

Because indoor spaces are frequently small, it is a good idea to bring along a short focal length lens if you plan on including a substantial amount of the environment in your pictures.

Available-light photography often calls for a freer approach than when you are controlling the light. Look all around for interesting backgrounds and choose a camera angle that takes advantage of what you find. Photo: H. Weber.

Available Light Indoors

Available-light portraiture indoors requires the use of fast lenses and films; your depth of field will be limited, and facial details will not come across as readily as they would with slower, higher-resolution films. Still, compelling portraits can be made under the dimmest of light conditions. Informal and environmental portraits usually are strongest when made in the existing light with no additional lighting.

Illumination. The precise placement of your sitter becomes more important in this kind of portrait than in some others. You have to make sure that he or she is lit properly by the surrounding light or you

will end up with an available-light interior photograph rather than a portrait. Sometimes you can ask your sitter to move near a convenient desk or table lamp, and shoot the portrait there without making any adjustments. Most of the time, though, you will have to adjust the available light—by tilting a lamp, changing its reflector or shade, or raising it slightly—until your subject is properly illuminated.

If your subject is sitting in an armchair or on a sofa near a table and lamp, you might find that the lamp is too low to illuminate the subject's face properly. Placing a thick book under the lamp will usually raise it enough without changing the visual effect of the area; and a white card held under your subject's face just outside the picture area will help throw some light back up into the shadow areas of the sitter.

Try to place your sitter so the lamp is outside the picture area. You can then tilt the shade of the lamp, or remove the shade entirely and use a homemade reflector to throw light onto the subject; then, from the other side, use a light piece of cloth or a card to fill in shadows.

If the lighting is incandescent, with bulbs of 100 watts or more, you will have enough light for moderate apertures and reasonably fast shutter speeds, even with medium-speed films such as Kodak Plus-X or Ilford FP4. If you are using tungsten-balanced color films, you will need to filter out the excess redness from the light, which means that the effective speed of your film will be reduced. Because of this, you will probably be better off shooting with films that have ISO/ASA speeds of 200 or more.

Film. Unless you want portraits with poor shadow detail and featureless highlights, avoid "pushing" conventional films. Using the film at a speed higher than indicated on the box and compensating in the development will give you an image, but rarely a good one. In most cases, fast black-and-white films such as Tri-X or Agfapan Professional 400 and color films such as Ektachrome 400 will be fast enough at the manufacturer's suggested speeds. If the conditions are extremely dim, use one of the new variable-speed black-and-white films—Ilford XP 1 or Agfa's Vario XL. These can be used at speeds up to ISO/ASA 1600, or even 3200, with good tonal rendition throughout the image. Both films require solutions similar to those used in color-film development for processing, and both are expensive compared to conventional black-and-white films.

If you do not mind grainy portraits, shoot with super-high-speed films such as Kodak Recording film (35mm) or Royal X (roll film). These are designed to be used at speeds above ISO/ASA 1000, and will generally give better tonal rendition than slower films that are underexposed and then overdeveloped. Kodak Ektachrome 400, when used at a speed of 800, can be processed for the increased speed if you ask for special processing from Kodak. The results will not be as good as those you would get if the film were used normally, but the increased grain and slightly paler color rendition might help the mood of certain portraits.

Tungsten Light

Tungsten photo lamps are specially formulated to produce a somewhat bluer, or "cooler," light than household, or "general service," incandescent bulbs give off. The degree of red or blue light given off by a light source is usually described in units of measure called *Kelvins (K)*. The higher the Kelvin "temperature" of the light source, the more blue it produces. Photo bulbs give off 3200K or 3400K, depending on their type, while household bulbs give off far less. Tungsten-balanced color films are designed to give natural-looking tones when used with specific light sources. Type B films, the most common, are balanced for 3200K lamps, which are the type used most often. Flood lamps and tungsten-halogen (quartz) lamps of 3200K are sold by most camera stores, along with a large selection of different size reflectors, diffusing materials, and other accessories.

Bulbs of 3400K are also available, though these are used less often. At present, there is only one film specifically designed for use with these lamps—Kodachrome type A, with an ISO/ASA speed of 40. To use the other films with these lamps, you will need an 82A (bluish) correcting filter, and about ⅓-stop more exposure; for a 3200K flood lamp used with type A films, you will have to add an 81A (light amber/yellow) filter and give ⅓-stop more exposure.

Unlike household incandescent lamps, whose color temperature depends on their wattage, photo lamps have the same color temperature no matter how intense their light output is. Tungsten-balanced film will produce the same result, in terms of color rendition, whether 250-watt, 500-watt, 750-watt, and even 1000-watt photo bulbs are used. However, these bulbs do drop slightly in color temperature as they get older, so that towards the end of their lives they produce redder results. The difference is rarely troublesome in portraiture, but it is a good idea to use bulbs of the same age during a session.

Tungsten-halogen or quartz lights are generally balanced at 3200K, and have the advantage of giving consistent color rendition, regardless of their age. Their disadvantages are that they cost more, require special fixtures, and give no warning before burning out. They also have a nasty tendency to explode or shatter if touched by human skin and then turned on—oils from the skin cause a pressure difference on part of the lamp's glass envelope as it heats up, and the tube literally comes apart. Be careful to use gloves or some other protection when you handle quartz tubes.

Because of their elongated shape, quartz tubes can be easily mounted in groups and placed behind a large piece of diffusing material to give a very bright, broad-based light bank. Such a bank is ideal in the studio or in some other essentially permanent location. Individual quartz lamps take up less space than equivalently bright tungsten photo bulbs and reflectors do, so they are easier to carry around on location.

Both quartz and tungsten lamps burn very hot, so be careful to mount them on sturdy stands, keep all wires away from feet, and do not touch the lamps until they have been turned off for 15 or 20 minutes. In the same regard, keep a close watch on all diffusing material you might hang in front of the lamps, and do not substitute them for incandescent lamps in someone's home unless the fixtures have extremely large shades that will not catch fire.

Screw-base photo bulbs of up to 250 watts are ideal for substitution in a home environment if you do so with care. They provide correct color balance for tungsten film, and usually give at least one more stop of exposure than household bulbs do, even in the most brightly lit rooms. Of course, the color balance will only be as good as the lamp shades allow it to be. If the shades are some distinct color, place your sitter far enough away from them that he or she is lit from the overall room light, and will stand less of a chance of having the shade cast its color onto his or her skin.

An inexpensive trio of photolamps, along with a reflector for each, will give you all of the illumination you need for most of your indoor portraits. These lamps provide a color temperature of 3200K, and will provide proper color rendition with tungsten-type color films.

Electronic Flash

Most professional portrait photographers who light with electronic flash have invested thousands of dollars in large, powerful flash units; in many cases, the results are worth the investment. However, it is reasonably simple to produce convincing, natural-looking portraits with a simple, on-camera flash unit. All you have to keep in mind is that small flash units emit a highly intense, narrow beam of light, and that they are primarily designed to be used close to the subject.

Softening Flash. When you point a small flash unit directly at someone and make an exposure, your result will generally be flat, harsh, and not particularly pleasant. To get good facial modeling and more pleasant shadows, you will somehow have to diffuse the light. The easiest way to do this is to attach a piece of white cloth, or a few layers of lens cleaning tissue, over the flash lamp. These will soften the light considerably. They will also lower the illumination by approximately

Umbrella bounce light is soft and full on a subject. Because it comes from a large area, you may not need a separate fill light—that is the case here. Photo: N. DeGregory.

one stop for each layer of white handkerchief or piece of lens tissue.

You can also soften the light by bouncing it from a light-colored surface—a ceiling, a wall, or a piece of white card. Which surface you use will depend on how you want the light to fall on your subject. In most cases indoors, you will be using your flash unit to approximate the illumination found in the room itself, or you will be trying to get the same lighting effect you would with tungsten lights.

For conventional modeling of your subject's features, the light from the flash should reach your sitter from above. If the flash unit has a tilting head, aim it at the ceiling, making sure that the bounce angle allows your subject to be lit properly. If you aim the flash incorrectly, most of the bounced light will end up behind your subject, or will come down directly over him or her, creating lighting problems similar to those encountered outdoors in noon sunlight—harsh lighting, with deep neck and eye-socket shadows.

If your flash unit is rigid, buy an off-camera bracket with a tilting head, or get a long extension cord that will allow you to hold the flash toward the ceiling while it remains connected to your camera.

Flash Exposure. Most bounce-equipped flash units are automatic; they have a sensor built into them to judge the amount of light reaching the subject. When enough light has been expelled for the proper exposure, the automatic flash unit stops the light output. This will only happen properly if the sensor faces your subject directly from the camera position, even though the flash is being bounced. If the sensor is located in a place on the unit where you cannot keep it aimed at your subject as you bounce the light, you will have to use the unit in its manual mode, and determine the correct exposure by measuring.

Correct flash exposure depends on the unit-to-subject distance, regardless of where the camera is located. All flash units have a table on them that indicates which aperture setting to use at various distances. If you are bouncing a manual flash unit, or an automatic unit in its manual mode, use your camera's focusing mechanism to measure the flash distance. First, from the position of the flash unit, on the area of the ceiling or wall from which you are going to bounce the light. Make a note of the distance. Then go to your subject's position, and focus on the flash bounce point from there. Add the two distances together; the sum will represent the total distance the flash will travel. Check the table on the unit for the correct aperture setting at that distance.

Shutter speed is important when using electronic flash. Because these flash units emit an extremely short burst of light, the flash may terminate before your shutter has a chance to open if the wrong shutter speed is used. Cameras with focal-plane shutters—most 35mm SLR's with interchangeable lens and some roll-film cameras—require electronic flash synchronization speeds of 1/60 sec., 1/90 sec., or 1/125 sec., depending on the camera. The "flash synch" speed indicated in your camera manual is the fastest shutter speed you can use with your camera. Slower speeds can be used with no problem. Leaf-shutter cameras will usually synchronize at all but the highest speeds.

Optional Features and Handling

Dedicated Flash Units. Many 35mm camera manufacturers sell "dedicated" flash units for their cameras. These are automatic units specially designed to perform certain functions with the cameras they are made for; some of them key in the correct shutter synchronization speed when attached to the camera's hot shoe, while others cause a "flash ready" signal to go off in the camera's viewfinder when the flash unit is fully charged and ready for another exposure.

All these features are helpful for general photography, but since most of the currently available dedicated flash units are made for on-camera use, they are of limited benefit in portraiture. All flash units used on camera give the kind of shadows produced by a tungsten or incandescent bulb placed at the camera position. Generally, the shadows will fall too strongly and directly on the subject, and both sides of the face will receive about the same amount of light. Electronic flash used near the camera with color film will also cause the subject's eyes to have red spots in them. The *red eye* effect will make your subjects look other-worldly at best. To prevent this effect, you must move the flash unit away from the camera position, or bounce it.

Here, diffused flash lights the subject fully, but falls off rapidly so that the background is dark enough to be undistracting. Photo: B. Bennett.

Flash Fill. The most useful kind of on-camera flash unit is the type that has a built-in fill light, a scoop, or some other means of dividing its flash output, so that some of it fills in the subject's shadow areas while the rest of it is bounced. Most of the time you can use units like this from the camera position and still get good illumination. The little bit of fill light (usually about 20 percent of the light output) is not enough to cause red eye, and it helps to brighten eye sockets and the area under the chin without destroying the effect of the bounced light.

Technique Tip: Creating Bounce Flash Fill Light

If you have a flash unit with a tilting head but no built-in flash-fill feature, try one of these methods.

1. Place a large white reflector as close to the subject as possible without being in the picture. Position the reflector parallel with the bounce surface, but just outside the opposite side of the picture area. That is, just below the frame if you are bouncing light from the ceiling, or just to the left if you are bouncing light from the right hand wall. The reflector will pick up excess bounce light and direct it into shadowed areas of the subject.

2. Use the tilting-head unit as a bounce flash key light set up away from the camera, and a less intense unit at the camera position as a fill light. In general, fill light should be no more than half as bright (at least one stop less) as the key light on the subject. Bouncing the main light effectively reduces the output of the key unit by at least one stop. So, the fill unit must have at least two stops less ($\frac{1}{4} \times$) *output* as the key unit for proper balance. You can achieve that in various ways:

 a) Use a unit of equal power, but with its variable output switch set for $\frac{1}{4}$ power.

 b) Use a unit of equal power at full output, but cover the head with two layers of white handkerchief material. Each layer reduces the light by one stop.

 c) Use a unit with a guide number $\frac{1}{2}$ that of the key unit. (Example: Key unit GN = 40; fill unit GN = 20.)

 d) Use a unit with a BCPS/ECPS rating $\frac{1}{4}$ that of the key unit. (Example: Key unit BCPS = 2000; fill unit BCPS = 500.)

Mixed Lighting

If you make your portraits in black and white, you can safely use any combination of light sources—tungsten with flash, daylight with candlelight, and daylight with room light will all work because black-and-white film responds only to the amount of light reaching it, not to the light's color balance.

Color portraiture is also possible with mixed light sources, but you will have to be careful. Mixing flash with daylight is simple enough; both will produce natural-looking results on daylight type films. You will have problems mixing tungsten lighting with daylight or electronic flash, though. If you mix them while shooting with tungsten-balanced color films, the daylight parts of the scene will look too blue; if you shoot with daylight films, the parts of the scene lit by tungsten lamps will appear too red. You can mix tungsten photo lights and household lights while shooting with tungsten films as long as most of the light—especially that falling directly on your subject—matches the film's color balance. The extra redness given off by the household bulbs will make the picture look slightly warmer than it should, but not disturbingly so.

Electronic Flash and Room Light. The mixing of light sources occurs most often when the photographer is making an electronic-flash portrait indoors and wants some of the feel of the room. A flash at the camera's synchronization speed might fall off directly behind the sitter, leaving the background in darkness. Use a low shutter speed—1/15 sec.

The slow shutter speed required for the existing light in this scene created a blur of the craftsman's mallet that contributes to the picture. Photo: B. Sastre.

Technique Tip: Special Effects for Color Portraits

For color portraits with special-effect lighting, you can mix or match films and lighting sources as you please. In most cases, skin tones that are too red will look less disturbing than those that are too blue—avoid using tungsten film for outdoor or flash portraits, especially if your subject is fair-skinned and/ or has red hair.

In the studio or other fixed location, you can change the tones of your background subtly by using "unbalanced" illumination. White walls can be made cooler or bluer by lighting them with a discreetly located flash unit, while the rest of the scene is lit with tungsten bulbs and shot on tungsten film. The same wall can be made warmer or redder if you make a long exposure using flash on the subject, but light the background with tungsten lamps. If your subject has reddish hair and you are shooting with tungsten film, you can accent the redness by placing a household bulb in the hair light instead of a tungsten photo bulb; just make sure that your subject's clothing is not light-toned, or the redness will become noticeable on the shoulders as well.

or 1/8 sec.—and the aperture recommended for proper flash exposure. This way, the flash unit will go off and quit when enough light has reached the subject, but the shutter will remain open long enough to allow some of the room light to register.

Flash and Daylight. Another common way to mix lighting, though not in terms of color balance, is to use flash outdoors, or indoors with window light. On days when the light is too harsh for good facial modeling, in noon sunlight, or at those times when you want to use daylight film for window-lit portraits but need a little extra light on your subject's face, do the following:

1. Set your camera shutter at the flash synchronization speed.
2. Using your camera's exposure meter, or a hand-held meter up close, determine the aperture necessary for proper exposure of your subject's main features with the shutter at the flash synchronization speed. Set the aperture accordingly.
3. Look at the distance calculator on your flash unit to find out how far away the unit has to be for good exposure at the aperture you have set. Place your flash unit at that distance —if it is nearer or farther from your subject than the camera is, you will need an extra long connecting cord. Focus your camera, frame, and make the exposure.

6

Lens Selection and Working Distances

You can make excellent portraits with just about any lens you own, although some lenses will produce better results in certain kinds of portraiture.

Lenses of different focal lengths have different angles of acceptance—that is, they take in more or less of the area in front of them, depending on their length and the film format of the camera. The standard, or "normal," focal length for a 35mm camera is from 40mm to 55mm in length. These lenses take in about as much area as your eyes do when you look around without paying particular attention to any one object. With roll-film cameras, the standard angle of view is provided by 80mm to 105mm lenses, depending on the film format of the camera. A 50mm lens on a roll-film camera takes in more than the standard angle of view and is called a *wide-angle* lens; on 35mm cameras, 80mm to 105mm lenses give a smaller angle of view and are considered moderately *long-focal-length* lenses. The standard focal length for a 4″ × 5″ view camera is 150mm, which would be considered long for both 35mm and roll-film cameras. In any event, lenses longer than standard for each camera type will give less subject area, but more magnification of the subject; lenses shorter than standard will give more subject area, but less magnification.

For each camera type, the shorter the lens, the more it will tend to distort the image, especially near the edges of the frame. In addition, perspective is distorted with short lenses—distant objects appear smaller than they do to the naked eye, while near objects appear bigger. Standard lenses produce an image size and perspective that our eyes are used to. Long lenses compress perspective, making distant objects appear closer to near objects than they actually are. This compressed perspective may come in handy in certain kinds of portrait making; it might enable you to make abstract patterns out of disturbing backgrounds.

The perspective produced by a normal focal-length lens complements the unity of direction in the composition of this portrait study. Photo: C. Child.

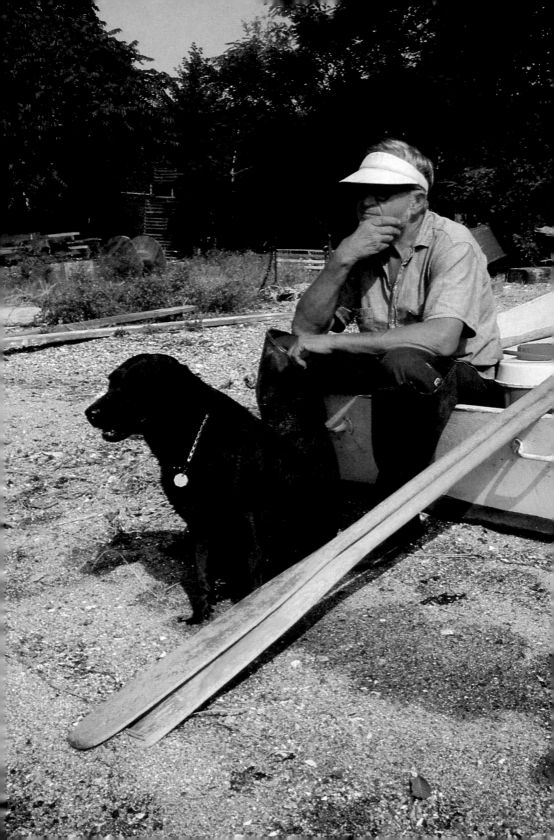

Portrait Lenses

Two completely different kinds of lenses are referred to as "portrait" lenses.

The first, which has been available for years, produces soft-looking images. These special "soft-focus" lenses render details of the subject sharply, but they are high in something called *spherical aberration,* a defect that causes halos of softness around the outline of the subject. Conventional camera lenses are designed to eliminate as much spherical aberration as possible; soft-focus portrait lenses are intentionally made with a high degree of this defect to produce romantic-looking subject outlines. Wedding photographers and commercial portraitists make good use of these lenses, which are of dubious use in general, personal portrait making.

Soft-focus portrait lenses produce less diffuse image edges when they are used stopped down. Some come with a group of perforated disks that slip into the lens barrel, providing various degrees of edge softness. You can get almost the same—although less-controlled—result by attaching a special filter with a clear center and a slight diffusion grid around its edges to a conventional camera lens. Many filter manufacturers make these lens attachments, which sell for far less than soft-focus lenses do.

The second so-called portrait lens is any camera lens that is from 1½ to 2 times the focal length of the standard lens for the camera. For 35mm cameras, lenses from about 75mm to 105mm in focal length are considered "portrait" lenses; roll-film camera portrait lenses range from 120mm to 150mm in focal length.

Generally, these slightly longer-than-standard lenses have relatively large maximum apertures, which allow you to eliminate unwanted background detail by throwing it out of focus. They are usually not much bigger or heavier than the standard lens your camera came with, and their slightly compressed perspective allows you to make closeups of your subject's head without distorting his or her features the way you might with a standard or wide-angle lens at a distance close enough to get an equally large image. Most lenses in this focal-length range focus as close, or nearly as close, as standard lenses do; using this lens type, you can easily fill your picture frame with someone's head while remaining at a reasonable distance. If you own a camera and standard lens, this is the next focal length to buy if you want more flexibility in your portrait photography.

Do not buy more lens than you need. If you have a choice, say, between an 85mm $f/1.8$ lens and a 100mm $f/2.8$ lens for your 35mm camera, consider how many times you will need the extra $1\frac{1}{3}$ stops of speed the shorter lens gives. Find out which of the two lenses is easier to hold and work with. Depth of field need not be considered because, while the shorter one has a larger maximum aperture, the longer one is going to give more or less the same depth of field.

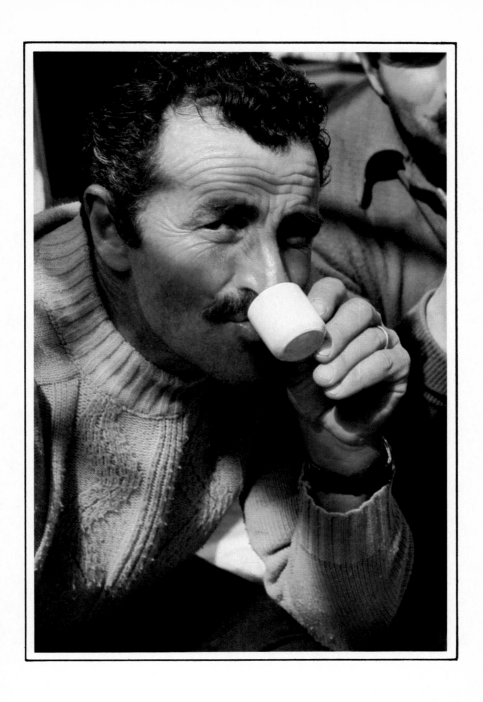

There is no reason why naturally-caused shadows should not fall across the subject's face. In general, though, be sure to keep at least one eye in bright light. Photo: B. Docktor.

Standard Lenses

When you first begin to make portraits, your standard lens will give the best results. In all probability it will be the lens that came with your camera and with which you are the most comfortable.

Standard lenses will make informal portraiture and environmental portraiture easier—their angle of view and degree of magnification are like those of your eyes, so there will be little lost between what you see and what the lens records. The depth of field with this type of lens, especially in the 35mm format, is good enough at all but the largest apertures to allow quick, fiddle-free focusing, and from about 2.5 to 3 m (8 to 10 ft), you can make head-and-shoulders portraits comfortably. A few steps closer will give a tighter view of your sitter; a few steps back, a full-figure shot.

All camera manufacturers currently making 35mm equipment have standard lenses in various aperture speeds. If you plan to do a lot of available-light portraiture, you will be better off with a standard lens whose largest aperture is $f/2.0$ or faster. Roll-film cameras rarely come with standard lenses faster than $f/2.8$, although a few are available with $f/1.9$ or $f/2.0$ lenses. Since roll-film cameras produce much larger negatives and slides than 35mm equipment does, the slower lens is not a problem—the bigger image gives better results with fast films, eliminating the need for super-fast roll-film lenses.

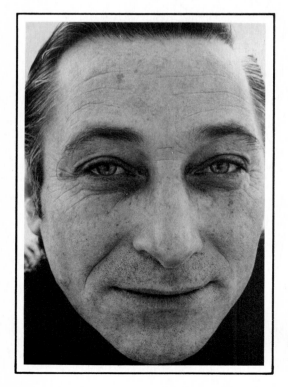

Do not come in too close with your normal lens while making portraits; facial features will become distorted, giving your subjects an unpleasant appearance.
Photo: F. Leinwand

Use your standard lens whenever your portrait making requires you to be mobile. Hand-held shooting is more reliable with these lenses than with longer ones, so you will be able to move from side to side, catching different angles of your subject as he or she moves, or as your mood dictates. When cameras are designed, they are usually made to balance best with standard lenses attached; therefore, your camera with its standard lens will become an extension of your hands and eyes faster than the camera with some other lens. In portraiture—as in any other type of photography—your success in translating the image in your mind to an image on film is easier when you can use your camera automatically.

Standard lenses do have one disadvantage. They focus close enough in most cases to provide full-frame head shots, but your results will be slightly distorted with the head out of shape. Most of the time this effect is subtle, but it can ruin the feel of your portrait. Compare the two accompanying photographs. The first was made with a 35mm camera and a standard lens; the second was done with a 35mm camera and a longer, "portrait-length" lens. If you saw the standard-lens picture on its own, you might not have noticed the distortion, but compared to the other, more natural-looking picture, the difference is obvious. If you shoot close to your subject with a standard-focal-length lens held at a sharp angle—from above or below—the distortion will be more severe. You will get far better portraits if you keep your distance with standard lenses, using them for head-and-shoulders pictures. Use a longer lens for tight shots.

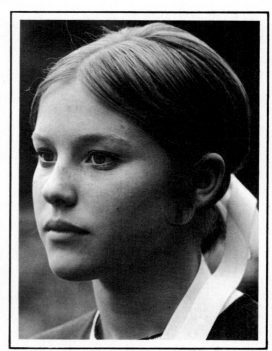

For undistorted, close views of your sitter's face, take advantage of the pleasing prespective given by lenses slighty longer than normal. For 35mm camera users, an 85mm or 100mm lens would be the best choice for this kind of work. Photo: F. Leinwand.

Long and Telephoto Lenses

You may have heard the words *long-focus* and *telephoto* used interchangeably—this is inaccurate. A long-focus lens has a long focal length and a proportionately long physical length. A telephoto lens uses a special design approach to achieve a long focal length with a considerably shorter physical length. Most long-focal-length lenses for 35mm cameras are of the compact telephoto design, for light weight and handling ease.

Lenses longer than about twice the standard lens focal length are ideal for informal portraiture outdoors. Their shallow depth of field eliminates distracting backgrounds, and the image seen in an SLR viewfinder through this lens passes in and out of focus quickly and definitely. At their closest focusing distances you can make portraits showing just your subject's eyes and mouth; from the same distance you would get a head-and-shoulders portrait with a standard lens.

For most 35mm portrait making, the most useful lenses are in the 135mm to 200mm range—longer lenses require you to be too far from your subject, and are too unwieldy and heavy for comfortable use. For extra reach in roll-film portrait making, use lenses from 150mm to 250mm.

Unless you are shooting in extremely bright light, a tripod or other camera support is essential with these longer optics. No lens should be hand-held at any shutter speed lower in number than its focal length (1/50 sec. for 50mm lenses; 1/125 sec. for 100mm lenses, etc.). With lenses longer than 135mm, you cannot be guaranteed of sharp hand-held results at shutter speeds lower than 1/twice the focal length; for example, do not hand-hold a 200mm lens at a shutter speed lower than 1/500 sec.

Long lenses have such shallow depth of field at large lens openings that it might be impossible to focus both the ears and the nose of the subject when making a head shot. Keep this in mind if you are deciding whether to buy a 200mm $f/4.0$ lens or to spend the extra money for a 200mm $f/2.8$ lens made by the same manufacturer. The slower lens will still have shallow enough depth of field at its maximum aperture for total control over the background. It will probably be sharper, since it will have less glass in its design, and will therefore be easier to manufacture with high resolution and contrast. Finally, it will be far less bulky and heavy, and the money you save will buy a lot of film.

The longer a lens is, the less able you will be to use it for informal or environmental portraiture. On the other hand, the longer lenses allow you to zero in on distinctive features of your subject's face, and the extra care you will have to take when using them will make your working routine more methodical and fruitful. Lighting mistakes such as improperly adjusted nose shadows and cross lighting become instantly visible when the long lens presents you with an enlarged view of your subject's face on the focusing screen.

Zoom Lenses. Zoom lenses are complicated optics that have continuously variable focal lengths. The same lens can act as a wide-angle, a standard, and a long-focal-length lens. With a zoom lens on your camera you do not have to stop and change lenses as the need arises; one turn of a ring on the lens barrel will provide the precise focal length needed.

Zoom lenses come in various ranges of focal length. The most useful for portraiture are those that cover moderately wide, standard, and moderately long focal lengths (35–70mm for 35mm cameras; 60–150mm for roll-film models). Until a few years ago, zoom lenses were optically inferior to individual lenses of certain focal lengths, but advances in lens design and materials have changed all that. In most cases, the zoom lenses of major manufacturers are every bit as good as the single-focal-length lenses—in some cases, they are better. Zoom lenses used to be huge, expensive, and heavy; now they are much smaller, easy to hand-hold, and quite reasonably priced, considering the fact that they do the work of two or three lenses.

One immeasurable advantage of zoom lenses, especially for those who make color transparencies, is their ability to be set at any intermediate focal length. When you use a zoom lens for portraiture, you can frame your subject exactly without having to budge from your camera position. You can set up your camera for a head-and-shoulders portrait with the zoom lens set at the middle of its range, then zoom out for full-figure shots and zoom in for head portraits by moving one control.

Zoom lenses are usually two or more stops slower than the lenses they replace, but for outdoor portraiture, or in situations where you have full control over lighting, they can make your photographic life a lot easier and your portrait sessions more productive.

Technique Tip: Using Zoom Lenses

It is easy to hand-hold a zoom lens at normal and short focal lengths, but at the longer settings it becomes a telephoto lens and requires proper support to produce sharp, vibration-free pictures. Especially in portrait work, it is a good idea to use a tripod with a long focal-length lens whenever possible.

For sharpest focus with a zoom lens, first zoom out to the longest focal length. This will magnify details to the greatest extent and give the least depth of field, so you can see the critical focus point most clearly. Focus the image, then zoom back to the focal length setting you want to use for the picture.

Controlling Distortion

You just saw how a standard lens can distort the head and face of your subject if used too close. The distortion is even worse when you try to make portraits using wide-angle lenses up close. The obvious answer is to avoid getting any closer than the point at which the lens begins to distort the image. It is not always easy to notice that point, however —especially if you become excited at the progress of your shooting session and inadvertently photograph up close. You might not notice that the subject's facial features are becoming distorted because, as you get closer, your eye and brain compensate for the distortion. You might only recognize it through the widest lenses.

If your camera has a provision for interchanging focusing screens, use one with a series of architectural grid lines etched in it (see the accompanying photograph). This will immediately show you when your subject's head, nose, or ears are becoming distorted. It will also indicate when you are tilting the camera too much, causing vertical lines in your picture to veer off into the corners of the frame. This is especially useful in environmental portraiture, or informal portraiture indoors where doorjambs, bookshelves, and the like may become part of the photograph. If the vertical or horizontal lines of these picture elements tilt unnecessarily, they will draw attention away from the subject. While you are concentrating on your subject's expression, or the way the light is affecting his or her face, it is easy to overlook something as seemingly unimportant as a bookshelf. The grid screen will help you remember.

If your camera does not have interchangeable focusing screens, a camera repair person might be able to adapt a screen for you.

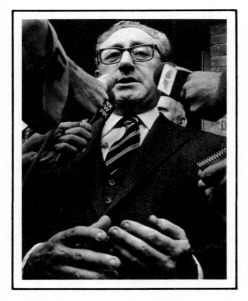

Wide-angle lens distortion is usually inappropriate for formal portraiture, but it can be very expressive in candid photographs that emphasize personality. Photo: J. Peppler.

Technique Tip: Avoiding Portrait Distortion

Any lens used closer than about 2.5 meters (8 feet) from the subject is likely to produce distortion in a portrait. This is because frontal features such as the nose and mouth are nearer the lens to be magnified more than the cheeks, eyes, ears, etc. The exact distance at which noticeable distortion begins depends in part on the lens used and the features of the subject. Distortion becomes especially noticeable if you enlarge only a portion of the negative to make a portrait.

The accompanying table shows how much various focal length lenses take in with various formats (Field Height) from a distance of 2.5 meters. The figures assume the format is used for a vertical rectangle, and allow for a small amount of space above the head in the image. Compare the coverage with the measurements given for average human beings.

LENS COVERAGE AT 2.5 M (8 FT) FROM SUBJECT

Field	Height	Format and Lens Focal Length (mm)			
cm	in	35mm (1"×1½")	6 × 6 cm (2¼"×2¼")	6 × 9 cm 2¼"×3½")	10 × 13ccm (4" × 5")
150	59	50	90	140	200
100	39	75	135	210	300
88	35	85	150	240	340
75	30	100	180	280	400
56	22	135	240	380	540
42	17	180	320	500	720
38	15	200	360	560	800

If you find yourself in a situation where you must shoot up close with a standard or wide-angle lens, keep the camera as level as you can to increase the chances for distortion-free portraits. If you can make a profile portrait that works, do so—profiles usually show less distortion than full-face portraits do.

When you are making indoor portraits of groups, environmental portraits that must include much of the surround, or other shots requiring the use of a wide-angle lens, be careful of round objects at the edges of your frame. Wide-angle lenses will sometimes distort objects such as globe lamps in the ceiling or plates on a cabinet shelf. The closer to the edges of your picture such objects are, the more distorted they will appear, seeming to leap out of the frame. Avoid getting them in the picture, if you can.

7

Accessories and Filters

Basic portraiture requires little more than a camera, a lens, film, and adequate light; many fine portraits have been made using nothing more. You might not think this was possible if you were to examine the accessory department of any major camera store. There are more types of accessories and gadgets offered for sale than there are people to buy them—even the photographic magazines have monthly columns describing the latest advances in photo-paraphernalia. Most of the items offer very little to truly improve your picture making. Some are useful, and a few are essential if you want complete control over your portraits.

The most important of these accessories are filters, for both black-and-white and color portraiture. The correct black-and-white filter can turn a bland sky into a dramatic background or make facial tones stand out properly against foliage. Using the right filter, you can even separate two tones that would otherwise print in the same shade of gray. Color-correcting and color-balancing filters help you match your film to the lighting type or add a little extra warmth or coolness to your portraits. Special filters such as polarizing filters control reflections in the areas surrounding your portrait scenes. Finally, filter gels placed over lamps change the lamps' color balance. In short, filters extend your photographic palette.

Other useful accessories include those that change the angle and direction of the light coming from your lamps. With the proper reflectors, shades, and grids, you can make a couple of ordinary flood lamps produce a multitude of lighting effects. With a few well-chosen lighting accessories, you can have the equivalent of a portrait studio waiting for you in your closet, ready to work whenever you are.

Dramatic effects can be achieved by using special filters. In this picture a small, intense light source was placed behind the subject and aimed directly at the camera through the crook of the arm. The photograph was then shot with a diffraction filter in front of the lens. Photo: B. Bennett.

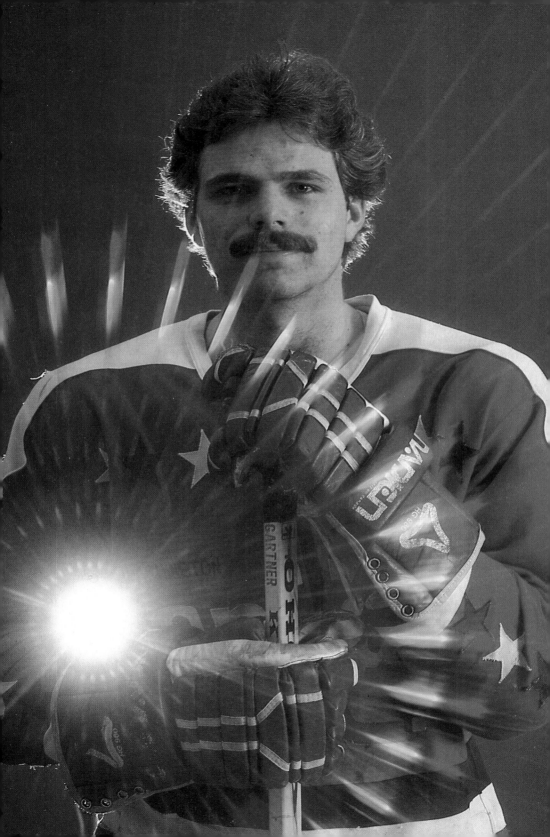

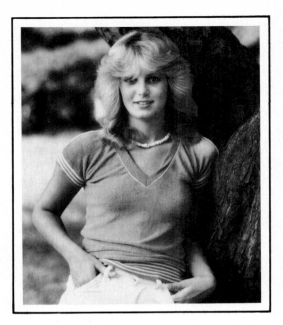

A pretty subject deserves a photograph that makes her come alive. This unfiltered shot is pleasant, but tonally weak. Compare it with the picture opposite. Photo: J. Schieber.

Filters for Black-and-White Portraiture

The filters used in black-and-white photography all do one thing—they lighten the gray tone rendition of any one object in the scene that is the same color as they are. They also darken certain other colors in the process. The most useful filters for black-and-white portraiture include the following:

Light Yellow and Medium Yellow. These filters, which lighten yellows and darken blues, are often used for portraits taken against a blue sky with white clouds. By darkening the sky, they cause the clouds to stand out. A light yellow filter will also produce more lifelike skin tones in outdoor portraits than would be achieved without a filter. Indoors, these filters can be used to add brightness to cream-colored or yellow clothing, and more depth to blue garments. When using the light yellow filter, add ½-stop exposure for outdoor use; do not increase exposure when using this filter under tungsten light. Medium yellow filters need ⅔-stop more exposure outside, ⅓-stop more under tungsten light.*

Yellow Green. This filter affects facial features photographed outdoors in the same way the light yellow filter does. It also lightens foliage for better separation of skin tones and greenery that appears

*Through-the-lens metering systems and automatic-exposure devices often misread the light passing through a colored filter, so make all exposure changes manually or reset the film-speed dial of automatic cameras to insure the right exposure.

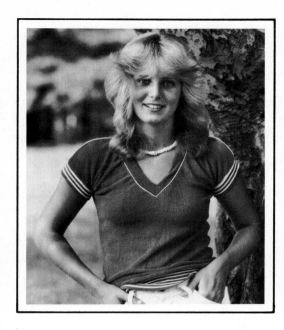

A light yellow-green filter added life by separating tones more clearly and adding contrast. notice its effect on the subject's blonde hair and skin tone, and on her light blue shirt. Photo: J. Schieber.

in the background. This filter darkens blues, reds, and violets. For outdoor use, increase exposure by 1 or 1½ stops. Under tungsten light, increase by ⅔ to 1 stop.

Orange. For contrasty, dramatic results that make the sky look as if a storm is approaching, use this filter. Essentially it works as a more intense version of a yellow filter. It lightens yellows, magentas, and reds and darkens blues, greens, and cyans. For daylight use, increase the exposure by 2 stops; in tungsten light, increase by 1 stop.

UV/Haze. These colorless filters, which require no exposure increase, filter out ultraviolet rays and reduce the effects of atmospheric haze. They are especially useful in the heat and at high altitudes. Some photographers leave a UV filter on their lenses at all times to protect against scratches and dust. It is a better idea to use a lens cap when you are not shooting—the filter adds an extra glass surface for light to pass through and might lower the sharpness of your results. Never use a filter unless you must.

Neutral-Density. These filters have no color cast of their own and act only to lower the intensity of the light reaching the film. They are most useful on bright days with fast film, when the fastest exposure your camera permits will still produce an overexposure, or on occasions when you need a specific *f*-stop and want to lower your shutter speed to match the synchronization speed of your camera. Neutral-density filters come in various degrees of density, from ½ stop to about 6 stops; the most common is between 1 and 4 stops.

Warming filters can be used singly or in combination with other filters. The portrait above was made without a filter, the one below was made with a warming filter. Note the changes in skin tone, hair color, and background. A star screen also used for both pictures created the reflected sun effect in the glasses. Photo: B. Bennett.

Color-Balancing Filters

The filters used to balance color films with a particular type of light are either cooling (bluish) or warming (amber/reddish) filters. To use tungsten films outdoors you must add amber or red to the light passing through the lens, or the film will record the tones in the scene with an overly blue cast. Because the nature of daylight changes as the day

wears on, you must choose the appropriate warming filter based on whether or not the sun is shining directly on your scene. A number of these warming filters are available.

If you use daylight film under tungsten or incandescent light, you can avoid an excessively reddish cast by using the appropriate cooling filter. These cooling filters are very dense—some must be used in pairs and require a considerable increase in exposure. Even if you filter the light as recommended, your results might not be totally satisfactory. If at all possible, use tungsten film indoors—the filtration for incandescent lighting with tungsten films is a lot more efficient and needs less of an exposure increase. Use daylight film indoors only with electronic flash, or as an absolutely last resort.

COLOR-BALANCING FILTERS FOR DAYLIGHT AND TUNGSTEN FILMS

Light Source	Daylight Transparencies/Type S Color Negative Films	Tungsten Transparencies/Type L Color Negative Films
Window light	None; or 81B + ⅓ stop exposure increase	85B + ⅔ stop increase
Photolamps (3400 K)*	80B + ⅓ stop	81A + ⅓ stop
Photofloods (3200 K)	80A + 2 stops	None, if bulbs are new; if old, try 82 + ⅓ stop
250W-300W incandescent bulbs (3100 K)	80A+82 + 3 stops	82 + ⅓ stop
200W incandescent bulbs (3000 K)	80A+82A + 3 stops	82A + ⅓ stop
100W incandescent bulbs (2900 K)	80A+82B + 3⅓ stops	82B + ⅔ stop
75W incandescent bulbs (2800 K)	80A+82C + 3⅓ stops	82C + ⅔ stop
Candlelight	Not Recommended	80C + 1 stop

*Type A, or photolamp lights, give off a color temperature of 3400 K; they are rarely used nowadays, but you may come across them. There is a special Kodachrome film (called, appropriately enough, Kodachrome Type A), which is balanced for this type of lamp. You don't need to add any filters if you use Type A Kodachrome with photolamps. To use tungsten-type transparency films with photolamps, add an 81A filter, and increase exposure by ⅓ stop. To use Type A film with 3200 K photofloods, add an 82A filter and ⅓ stop more exposure.

Closeup Attachments

Most camera manufacturers offer a series of closeup lenses that are mounted onto the front of the camera lenses, allowing you to get closer than you normally can. While it is best to use a macro-focusing lens to photograph sections of a sitter's face, some closeup attachments are a passable, cheaper alternative for occasional use.

Closeup attachments come in a series of diopters, or magnifications. Most can be coupled with one another to provide even greater magnification than each gives alone; when combined, though, they rarely produce adequate sharpness and require you to be so close to the subject that you almost touch the area you want to photograph. Used individually they can be useful, especially if your portrait consists of a series of pictures, one of which shows a head-and-shoulders view of your subject and the others of which celebrate the person's individual attributes.

Some closeup attachments are meant to be used with long-focus lenses whose close-focusing distance is too great even for head-and-

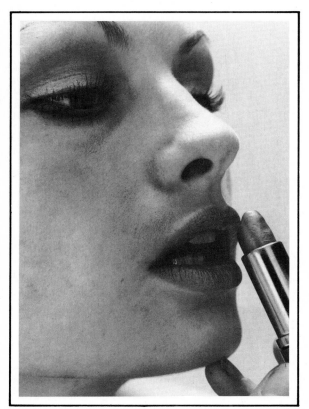

Auxilary closeup attachments extend the close-focusing range of most lenses. They take up no more room in your pocket or gadget bag than would a filter, and provide good results when used with the lens closed down one or two stops.

shoulders portraits. Many long lenses for roll-film cameras have this disadvantage, and some camera manufacturers have provided closeup elements to overcome the problem. Rollei makes a series of such attachments called *Rolleinars* for their twin- and single-lens reflex cameras; the ones designed for use with Zeiss lenses on Hasselblad cameras are called *Proxars*. Attachments such as these extend the scope of your lenses and maintain good sharpness as long as you stop down the lens a bit. If you use them with the lens at its maximum aperture, the edges of your photographs will not be sharp.

Avoid close-focusing attachments made by independent manufacturers; they are not computed for specific lenses and will generally degrade the sharpness of your images. Most camera lenses focus close enough so that the attachments are unnecessary, and if you own a Hasselblad, a Rolleiflex, or another top-quality camera, there is no sense in lowering the astonishing quality of their lenses with cheap attachments. If you must use closeup attachments with these cameras, spend the money for the proper ones.

For more extreme closeups and higher image quality, use auxiliary extension tubes. These are usually available in a series of different lengths, giving you a choice of subject magnifications. Only the shorter tubes will be of much use in portraiture, for closeups of facial features such as eyes or lips.

Special-Effects Attachments

Soft-Focus Attachments. These filter-like devices have minutely etched surfaces that break up the light entering the lens and cause a soft rendition of the subject. The image produced does not look out of focus or foggy; rather, it is similar to that produced by an old-fashioned "soft-focus portrait lens." Outlines of the sitter become haloed and misty, while the overall sharpness of the image is only slightly reduced.

This device is useful to produce pleasing photographs of people with skin problems, or to give any portrait a soft, romantic mood. Soft-focus attachments come in a variety of strengths; the weakest is most useful for portraits. These attachments soften not only the look of your portrait, but also the color rendition in it—colors look more muted and pastel.

Some soft-focus attachments have a clear center, so that the middle of your picture stays completely sharp, while the edges soften; as you stop down the lens aperture, the image becomes sharper overall.

You can easily make your own version of this device by placing a stretched piece of sheer nylon stocking across your lens. A similar effect will occur if you put some vaseline or other clear salve onto the front surface of a clear filter, leaving the center of it unsmeared. In a pinch, you can sometimes soften an image overall by attaching a clear filter on the front of a lens and breathing on it. *Never* breathe directly on the lens.

Star Filters. Known by names such as *Crostar* and *Variocross,* these filters break up the highlights in your pictures so that they reproduce as bright crosses. The effect is more diffuse at wide apertures and becomes sharper as you stop down the lens. Use these filters sparingly—their effect has been seen in so many advertisements and commercials that it has become trite.

Repeaters. As their name suggests, these give a number of images of the subject on one piece of film. Repeaters, or multiple-prism filters, break up the image into three, four, or more identical segments, depending on the filter. Some arrange the images in a circle, others in a diagonal line.

Teleconverters. You attach these optical devices between the camera and the lens to double or triple the lens focal length. The ones made by the camera manufacturer are fine, as long as you use them with the lenses they were designed for. Independently made teleconverters sometimes give good sharpness when used stopped down, but they are rarely built well. Those that are especially shoddy in construction might damage the lens flange or the meter-coupling prong of your camera.

Matt Boxes. These are essentially housings that slip in front of the lens and hold differently shaped cutouts far enough away from the lens to record the shape on film. The image appears outlined by the shape at the front of the matt box. It is the device that produces the traditional wedding photographs of the bride and the groom holding each other inside a heart-shaped or keyhole-shaped cutout.

Soft, flat lighting complements the romantic quality produced by soft-focus attachments. Photo: R. Farber.

8

Special Considerations

It does not matter whether you make your portraits with an 8″ × 10″ view camera or a 110 pocket camera, successful pictures depend on how well you put your sitters at ease and encourage them to drop their defenses.

Everybody has defenses. Think of the last time you were at a job interview. You behaved in a way you felt would best indicate to your prospective boss that you were the person for the job; you put on your "best face" by showing enthusiasm, politeness, and various positive expressions, all the while hiding your nervousness and discomfort. If the interviewer was good at his or her job, you soon began to relax and let your true value as a potential employee come across. You might have noticed that the questions asked were posed in such a way that you gave answers you might have otherwise hesitated to give. If the interview was effective, you came away with a better understanding of the position and your qualifications for it, and a good feeling about the experience. If it was not, you left feeling more nervous than you did going in.

In many ways, a portrait session is similar to the situation just described. You, as the photographer, are the "interviewer," your sitter is the one being interviewed. Your job is to find out what kind of person your subject is, and how best to convey what you have found.

There is no one way to approach this; each subject will give you a new set of problems and challenges. Some people act reserved and shy, reluctant to open up in front of the camera; others try to hide their uneasiness by chatting about the weather, your equipment, and so on. Getting underneath the defenses will be very difficult unless you immediately let your sitter know that he or she is important to you as a person, not just as a photographic object.

Gone are the days when everyone posing for a portrait had to say "cheese" for the photographer. Allow your subjects to be themselves; fine, direct pictures can be made of people who simply don't feel like smiling. Photo: W. Hodges/West Stock Inc.

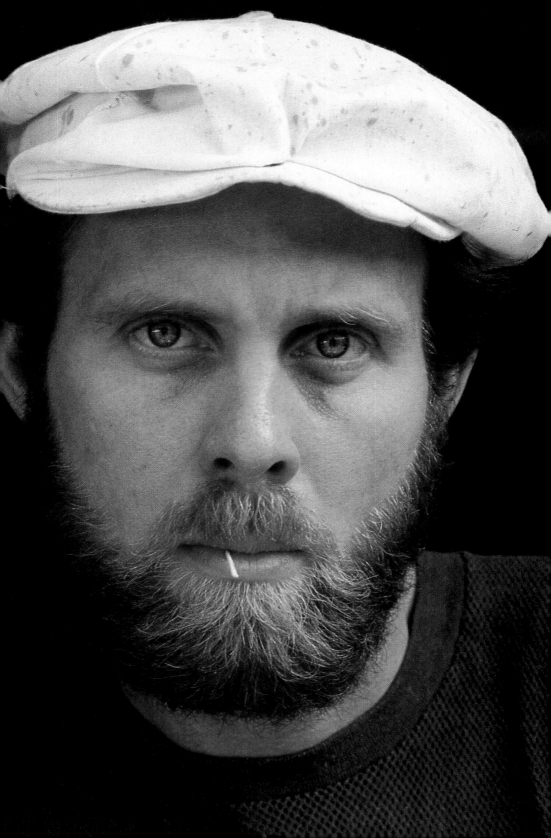

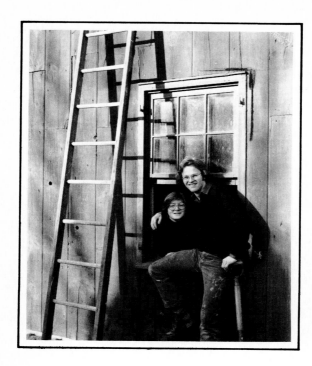

Attitudes are infectious; if you are enjoying the picture-taking situation, the chances are the subject will enjoy it too. Using a subdued sense of humor, especially about yourself, is a good way to ease tension. Photo: J. Alexander.

Directing and Relaxing Your Subject

Try as hard as you can *not* to think of a gorilla. Impossible? Of course it is, once the suggestion has been planted. Imagine, then, what happens when a beginning photographer asks his or her portrait subject *not* to be tense. Saying "Relax!" is just as bad. The sitter becomes self-conscious about being nervous and even more ill at ease. The only sure way to help your sitter relax is to act in a relaxing manner. You must watch what you say and how you say it. If you speak calmly, with a friendly and interested tone of voice, your subject will be much more likely to relate to you as a person instead of a photographer.

You cannot fake interest—most people will see through a false show of enthusiasm. If you have a chance, get to know something about your subject before you attempt the portrait. Learn about his or her career, hobbies, likes, and dislikes, so that you have some knowledge of where to steer the conversation. If you do not know the subject, talk about something that belongs to the person. An unusual piece of jewelry or clothing, the aroma of your subject's pipe tobacco, or the way your female subject has her long hair fastened or braided are all topics that will help establish some ease between you and your sitter. People tend to relax more when being photographed if they are encouraged to discuss something about themselves that is not too personal.

Young people are often very self-conscious, particularly about things like braces on their teeth. You can help direct their attention away from themselves with conversation about things you are both interested in. Photo: F. Davis.

Technique Tip: Corrective Action

Here are some ideas for coping with specific problems in a subject's features.

- Long nose, angular nose—Have the subject face the camera directly; use a lower than usual viewpoint.
- Prominent ears—Position the subject so one ear is out of view, keep other ear in shadow.
- Wrinkles, creased skin—Use broad, diffuse light at a ratio of no more than 1:2.
- Double chin, neck wrinkles—Use a higher than usual viewpoint; keep the subject's neck in shadow by raising the key light.
- Deep-set eyes, protruding brows—Use broad, diffuse light at eye level or slightly below; use a lower than usual viewpoint.
- Facial defects—Position the subject so they are out of view; keep the lighting ratio low (1:2 or less); keep defects on the camera side in shadow as much as possible.

Gaining Your Subject's Trust

In the ideal portrait session, you should have to do nothing more than determine your exposure, focus, and shoot. Much of the time this will not be possible, since you will be making some of your portraits at locations away from your home and will have to set up a tripod and lights. Even if you are shooting at your home, you might not know beforehand what lighting scheme will work best. Still, everything you think you will need should be ready for use.

The two fastest ways of losing your subject's trust are to make the job of photographing appear difficult and to make it mysterious. In the first case, many people will assume that the reason you are having trouble is because of them, not because you are ill at ease with your own equipment. The more self-confident subjects will assume you are inept, and will lose interest in the session. In the second case, nervous subjects will only become more tense if you wave light meters at them without explaining what you are doing or if you mutter unfamiliar photographic phrases under your breath instead of carrying on a normal conversation. If your sitter is interested in your equipment, talk about it without being condescending or unnecessarily technical.

Technique Tip: Using a Portrait Mirror

A large mirror will let your subject check expression, pose, and appearance throughout a portrait session. Used correctly, it can be a help, not a distraction.

- In general, place the mirror as close to the lens as possible, on the side the subject is facing. But make sure it is positioned so that the subject will not be tempted to shift or turn in order to see him or herself.
- Make sure nothing distracting behind the subject is reflected in the mirror.
- Adjust the lights so the subject can see the mirror image without straining or squinting. If you are using a strong key light at the camera, the mirror may not be usable.
- Watch for signs that the subject is becoming too engrossed with the mirror image, or is becoming self-conscious. If you sense that, just step in front of the mirror—without calling attention to the fact—as you talk to the subject. Get attention shifted back to you, then move your face to attract the subject's gaze in the direction you want.

If your subject is curious about the way he or she looks in the lighting you are using, make a print with an instant camera or set up a mirror near the camera lens. Instant prints can be a blessing or a curse, depending on the nature of the subject. If he or she is nervous about his or her appearance, and the picture is unflattering, you may end up with increased resistance to the actual shooting. On the other hand, if the instant picture turns out well, you will have broken the spell of nervousness and your subject will be all the more cooperative.

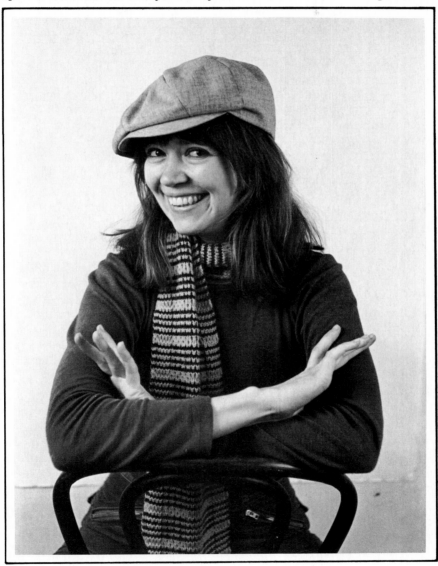

A spontaneous gesture and expression like this will last only for a moment. To be sure of catching it, complete all your technical preparations before you begin photographing your subject. Photo: H. Hankin.

Elderly People

Before you photograph an elderly subject, find out as much as you can about him or her. Is there a physical ailment you should know about? Even slight cases of lumbago or arthritis can make extended sittings difficult and painful; a slight hearing loss will require that you speak louder than normal when giving directions. There may also be other conditions that will affect how you approach the shooting. In some cases, older subjects will not have the stamina or willingness for long sittings, so come to the portrait session prepared and make it as short as possible.

Older people do not all have the same personality traits—each person will have his or her own degree of nervousness, vanity, and willingness to participate in the shooting. If your elderly subject is outgoing and gregarious, you can go about making the portrait as you would with any other subject; if, on the other hand, he or she is especially nervous in front of the camera, the session might be easier if someone familiar to your subject is there. Place this person near the lens, and let your subject and his or her friend interact while you wait for the right moment to make an exposure.

The life experience of your older subjects shows in their faces, but deep lines and wrinkles alone are not enough to make a good portrait. Be careful to light your subject so that he or she comes across as an individual, not just a collection of facial lines. If you do not want to emphasize your subject's skin texture, avoid direct light and sidelighting; indoors diffuse your key light with a piece of translucent material, or bounce it through an umbrella to soften the effect. Pay close attention to the subject's eyes. Are they bright and lively, or lifeworn? Place your main light so that there is a small reflection of it at the edge of your subject's pupil—this "catchlight" effect will add life and sparkle to the portrait. If you are bouncing the main light off an umbrella, point the umbrella stem at an angle that is in line with your subject's eyes; this will make the catchlight fall in the right place.

Older people generally live their lives at a slower pace, and their more sedentary pursuits create numerous opportunities for informal portraits. With a long-focus lens you can make intimate character studies, environmental portraits, and informal portraits without distracting your subject too much; just remember to get his or her permission first.

Unless there is a compelling reason not to, keep the camera at your subject's eye level when you shoot. A shot from above or below will exaggerate the features and might cause your subject's physical attributes to overshadow his or her psychological ones. Of course, rules are meant to be broken, and this is no exception: if your subject looks stronger with his or her features portrayed from a high or low angle, fine—as long as the viewers of the photograph learn something about the subject, rather than just noticing how the picture was made.

When photographing at short camera-to-subject distances, the depth of field will be shallow, even at a small aperture. Darken the tones of out-of-focus areas to de-emphasize them. Photo: J. Peppler.

Technique Tip: Eyeglasses

Here are some additional points regarding eyeglasses in portraits.

- Make sure the top edge of the glasses does not cut across the subject's eyes. If necessary, ask the subject to push the glasses farther up on the bridge of the nose, or to tip his or her head back slightly. Alternatively, lower the camera position; a very small change will do the job.
- Be careful that solid, wide rims do not cast distracting shadows on the subject's face. This is most likely to occur with spotlights or direct flash; use diffused, reflected, or bounced light instead.
- Often reflections can be eliminated by asking the subject to tip the glasses downward a bit, without moving his or her head. This is especially easy with women because their hair will conceal the raised position of the temple bars of the glasses.
- If glasses are an important factor in the subject's usual appearance, or if they reveal some aspect of character, use a pair of rims without any lenses in them. That is a common trick in movies and television. You can get many kind of rims quite inexpensively from many retail outlets.

Couples

In one way, making portraits of couples is easier than photographing individuals. People portrayed in pairs are usually familiar enough with each other to alleviate one another's nervousness in front of the camera. Portrait sessions seem to go faster for couples than they do for individuals because couples tend to interact naturally without much prodding from the photographer.

Lighting couples is more difficult than lighting single portrait subjects. Not only are the problems with nose shadows and background shadows doubled, but careless placement of the lights or the subjects might cause shadows to combine unpleasantly or unwanted shadows to be cast on one subject by the other. Use broad-based lighting. A light bank or lamps in large reflectors, covered with diffusion material, will illuminate both subjects to the same degree. Make sure your reflectors or fill lights are large or powerful enough to do this also. If you are shooting outdoors, the main light will obviously not be a problem—just make sure that both people are lit evenly and that they do not get in each other's way. A large white cloth or a piece of white card can be used to reflect fill light onto both people if you are making head-and-shoulders or head portraits. If you want full-figure shots, make your pictures on a clear, cloudless day, or bring along a white sheet (and someone to help hold it) to reflect fill light.

Directing two people is not much more difficult than directing one. In many cases, you will find that the way your subjects naturally position themselves with one another is best for your portrait—all you will need to do is ask for an occasional turn of the shoulder or tilt of the head to catch the light properly. Since your sitters will be giving one another mutual support throughout the session, they will usually respond to your placement suggestions better than single subjects. Ask for their suggestions as well.

If you are making the portrait at the couple's home, ask them to sit where and how they normally do. If there is a location where they generally sit together, make a few pictures there, then move to other locations. If they sit at opposite ends of the room, use a wide-angle lens to photograph them and the room—you will, in effect, be making an environmental portrait of a family at home. Having done this, ask your sitters to take turns being photographed near the other as he or she sits in a favorite place. Making your first pictures where your subjects usually relax helps break the ice and makes them receptive to your suggestions about other locations.

Let your subjects choose the topic of conversation. Once they have gotten used to your presence, they will probably converse as they normally do; this is when your best pictures are likely to occur. Pay attention to the way they behave with one another, how close their bodies get, and how they look at each other; make your exposures when these moments seem most representative of their relationship.

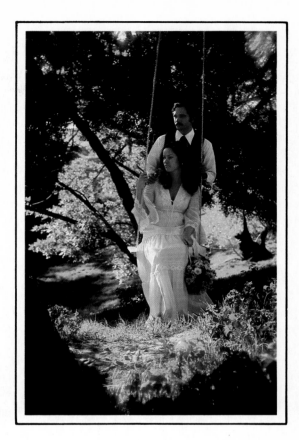

Use technique as well as setting to enhance the mood of your portraits. A diffusion filter with a clear center adds to the feeling here. Photo: J. March.

If you keep a moderate distance, your sitters will get used to your presence faster and become more easily absorbed in one another. For head or head-and-shoulders shots, use your standard lens or a moderately long-focus lens from about 2 m (about 7 ft). The standard lens used at this distance will give you head-and-shoulders shots with enough surround to let you frame the photograph as you like it, while the long lens (about 90 mm to 100mm for 35mm cameras; 150mm to 180mm for roll-film cameras) will provide you with full head shots.

Place your subjects so that there is no unnecessary or distracting space between them, or else your supposedly integrated portrait might end up looking like two separate portraits on one roll of film. In order for a portrait of a couple to work, there must be some connection between the people in the photograph—a gesture, a look, whatever it takes to convey to viewers that these people are not together by accident. This tie will be expressed at moments throughout the portrait session if the session is successful; the trick is to photograph the subjects when it is expressed to the greatest extent.

Group Portraiture

Unless you are making pictures in a clone factory, there is no way to capture the essence of more than one or two people at a time. Fortunately, no one will expect this in group portraits; most of the time, such pictures will be of the formal or the environmental variety—the documenting of a graduating class, a victorious sports team, or a wedding or christening party. In situations like these, you will generally have to provide a photographic document of the people involved in the event; you will be concerned with fulfilling the assignment efficiently and making interesting photographs.

Having individuals within a group touch one another—a hand on the shoulder is sufficient—gives a feeling of togetherness. Photo: J. Alexander.

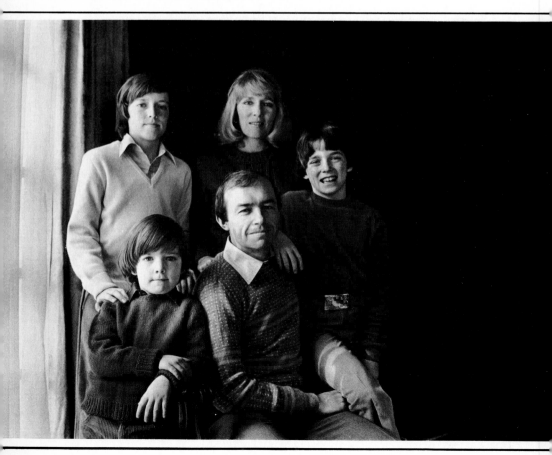

The technical problems in lighting large groups with household lighting are enormous—you would need more lamps and reflectors than even the most ambitious amateur has, and placing them so that everyone in the picture was lighted correctly would take too long. The easiest way to light large groups is to supplant the existing light bulbs with photoflood bulbs—most group portraits involving many people are made in reception halls or other large areas with plenty of light fixtures. One or two additional flood lamps from the front will add extra light at the edges of the picture if the room illumination falls off there. If you are making the portrait with electronic flash, use a wide-angle diffuser over the flash lamp to spread the light evenly over your subjects.

Technique Tip: Photographing Groups

Your problems multiply rapidly as the number of people in a picture increases. You need to keep things well under control in order to get a true group portrait rather than just a snapshot of a bunch of people.

- Use a directed arrangement. People may pose themselves acceptably, but they cannot see how they look in the overall group; you can.
- Informal arrangements, such as sitting around a living room, work well up to about five people. Beyond that number, a formal arrangement—in staggered rows, for example—makes a better picture and keeps things under tighter control for you.
- In a formal arrangement, have everyone face in the same direction and arrange their hands and feet in the same manner. Uniformity of pose will make the diversity among the faces more apparent.
- Keep faces as closely grouped as possible to minimize brightness differences and to keep them all within the depth of field of your lens.
- Use broad, general light. With artificial light sources, bounce the illumination off reflectors or the walls and ceilings. Direct, specific (hard) light will create hard, confusing shadows of one person on another.

Get a young subject actively involved in something she or he thinks is fun, and you'll have no problem getting spontaneous expressions.

Children

As a rule children are less self-conscious about being photographed than adults, especially if you present the prospect as a game or a joint project. Let the kids look through your camera; show them how to press the shutter, and get them to make a picture or two of you before you begin photographing them. Try to make the portrait session fun for the children. If you can, avoid posing or directing young sitters. Never try to make portraits of kids whose trust you do not have—the pictures will be unsuccessful every time, and you might scare the child in the process.

You need not have read Piaget or Dr. Spock to be a good child portraitist, but you must like children, feel at home in their presence, and be able to let them know it. You also need patience, an ability to conjure up games and stories to fit the child and the picture situation, and a good sense of the particular youngster's attention span.

Informal portraits are easier than formal ones if your subject is a preteenager. Try to put the child in an area and give him or her something to do—drawing, a board game, or whatever—so you will have a captive subject who will stay still long enough for at least a few exposures. If there is a pet around, your job will be that much easier; most children love small animals and will ignore you and your cameras in favor of a puppy, a kitten, or a gerbil.

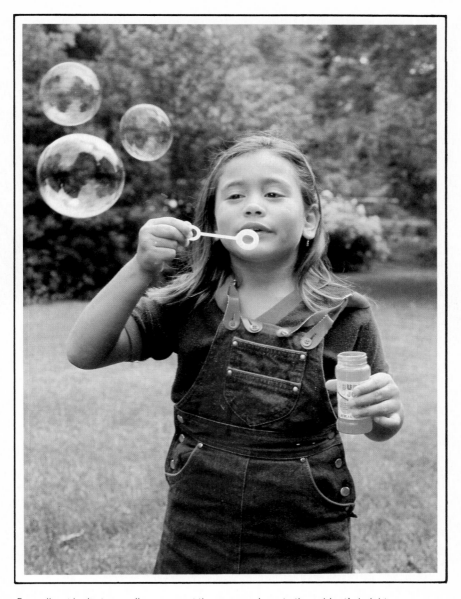

For a direct look at a small person, get the camera down to the subject's height.

To get and keep the attention of small children in situations where you want them looking at the camera, tell a favorite story and keep looking directly at the child while putting your face near the lens. If you tell the story well, the child will look at you and will appear to be looking into the camera. Use a cable release to trip the shutter, making exposures at the key parts of the story, when the child's expression is likely to change.

Index